MICHAEL FREEMAN
THE EXPOSURE FIELD GUIDE

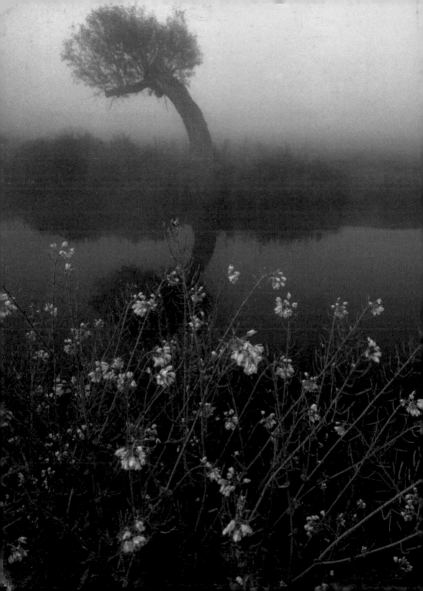

MICHAEL FREEMAN
THE EXPOSURE
FIELD GUIDE

The **essential handbook** to getting the perfect exposure
in photography; any subject, anywhere

ELSEVIER

AMSTERDAM • BOSTON • HEIDELBERG • LONDON
NEW YORK • OXFORD • PARIS • SAN DIEGO
SAN FRANCISCO • SINGAPORE • SYDNEY • TOKYO
Focal Press is an imprint of Elsevier

Focal
Press

Focal Press is an imprint of Elsevier

30 Corporate Drive, Suite 400, Burlington,
MA 01803, USA

This book was conceived, designed, and produced by
Ilex Press Limited
210 High Street, Lewes, BN7 2NS, UK

Publisher: Alastair Campbell
Creative Director: Peter Bridgewater
Managing Editor: Natalia Price-Cabrera
Editorial Assistant: Tara Gallagher
Editor: Steve Luck
Senior Designer: James Hollywell
Designer: JC Lanaway
Color Origination: Ivy Press Reprographics
Index: Indexing Specialists Ltd.

Trademarks/Registered Trademarks
Brand names mentioned in this book are protected
by their respective trademarks and are acknowledged

Library of Congress Cataloging-in-Publication Data:
A catalog record for this book is available from
the Library of Congress.

ISBN: 978-0-240-81774-3

For information on all Focal Press publications
visit our website at: www.focalpress.com

Printed and bound in China

10 11 12 13 14 5 4 3 2 1

CONTENTS

Introduction

Choosing the exposure for a photograph is both alarmingly simple and infinitely complex; in fact, it's one of photography's most absorbing paradoxes.

It is simple because there is ultimately only one dosage of light, controlled as it always has been, since the first view cameras carrying wet plates, by a shutter speed, an aperture, and a film speed. There are no qualifications or subsets, just a fraction of a second, an *f*-stop, and an ISO sensitivity. However much agonizing and philosophizing anyone puts into the equation, choosing the exposure still comes back to the same three simple settings—nothing else.

It is also complex because it affects everything about the image and its effect on those who see it. It reaches deep into what the photographer intended and why the photograph was taken in the first place. There are endless subtleties in the brightness, readability, and mood of every part of every scene, as witnessed by the different exposure decisions that different photographers take.

Understanding how and why exposure works as it does is worth a lot of effort, not only because it helps you to get it "right" at will and with total confidence, but also because it helps you decide what "right" is—and that's much more important in photography.

RICH CONTRAST

Prayers in a Burmese temple, lit by strong afternoon sunlight. The dynamic range is very high, but that's all to the good, because keeping the shadows almost pitch black helps the subject pop out. Overexposure would be the worst thing possible.

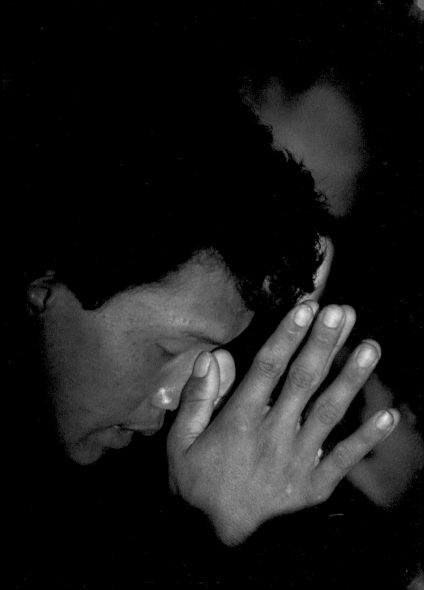

FAST-TRACK & FOOLPROOF

When it comes to photography, you should beware of any self-proclaimed "system." Systems tend to be invented and promoted either by photographers who have a very particular way of working that might suit themselves perfectly but is not necessarily adaptable, or by people who have little experience of the practicalities of shooting.

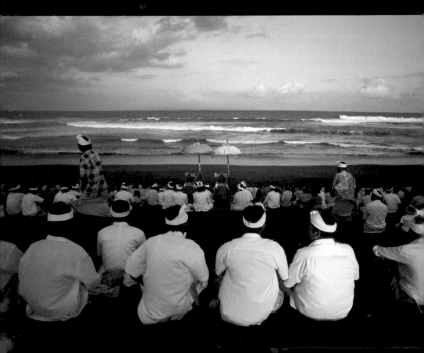

FAST-TRACK & FOOLPROOF

9

Technical

The Twelve

Style

Post processing

Reference

I write this knowing full well that I'm presenting here what looks suspiciously like just such a creature. The difference is, and my justification also is, that this is a distillation of the ways in which many professionals make exposure decisions. Most professionals, of course, do not use what they would ever themselves call a system, but when you live, breathe, and shoot photographs for a living, day in and day out, you develop and hone ways of working that behave very much like a system. Well, I would say that, wouldn't I?

As usual, my model for this book is the way in which professional photographers do things. "Professional" means someone who shoots on assignment regularly for a living, and I believe this is important. Not that professionals have any special dispensation to take better photographs. That kind of talent can rest innately with anyone, and be improved by anyone, though, of course, successful professionals are exploiting that skill. No, what makes the professional approach worth following is that we do photography all the time, and under pressure to deliver the goods every time.

In a slightly unusual departure from most of my books, I've carved out a short and succinct first chapter that is partly a summary of what follows, and partly a way of stressing the decision flow. After this I'll go into much more detail about individual aspects of exposure, all of which will take much longer to read than to do. Here, for the next few pages, I want to be completely practical and acknowledge that when you are shooting there is usually not much time at all for anything. Exposure decisions normally have to be made very quickly indeed, often without consciously thinking them through. But the decision flow is still there, however there is a short amount of time for it. This, then, is how it really is...

HOLD THE WHITES
Overall, the different blocks of brightness average out, but it was critical to avoid clipping the highlights on the two foreground shirts in this Bali scene.

GOOD FLARE
Although usually considered a fault, and something that manufacturers try to reduce with lens coatings, breaking the rules can sometimes help mood and composition. A string of flare polygons over a Montana Lake.

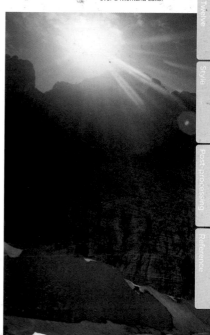

The Basic Method

I'm taking a slightly different approach in this book by trying to explain everything at the start, and as concisely as possible.

There are many different aids to exposure, and as many preferences among photographers for choosing camera settings. Camera manufacturers are well aware that this is the crucial issue for most photographers, so they have developed a raft of technical solutions, with each trying to outperform the others. The result is a wonderful choice, but also a chaotic array of methods, many encumbered by jargon.

I plan to cut through this nonsense, and my model is, as always, the way professionals like myself think and work. Being a professional photographer does not mean that the work is any better than that of a dedicated amateur. Actually, often the opposite is the case. What it does mean, though, is constant and realistic attention to shooting on a daily basis.

Let's start with the absolute summary, as concise as I can make it. Yes, there are all kinds of decisions embedded in each of the steps, but I will explain these later in the book. I've also had to allow for the many ways in which a modern digital camera allows the exposure to be set. An important point here is that it is usually less important which method you use than being thoroughly familiar with it.

In time sequence, this looks like the Decision Flow chart (opposite), which is a streamlined version of the full flow shown on the following pages. Follow the sequence and you will get the exposure as good as it possibly can be. The only qualifications are these: the first and last are mechanical, while all the rest require judgment and improve with experience... except number three which can take a lifetime.

Summary

1. SETTINGS
Make sure all the relevant camera settings are as you require them.

2. METERING MODE
Set your preferred metering mode and know how it will perform under the lighting conditions.

3. KNOW WHAT YOU WANT
Imagine in advance how you want the brightness distribution of the image to be.

4. SCAN FOR PROBLEMS
Quickly assess what the issues and likely problems will be, particularly the scene's dynamic range relative to the sensor's capability and if the light levels are low.

5. KEY TONES
Identify the areas of the scene that are the most important for brightness.

6. RISK OF CLIPPING
If the scene's dynamic range exceeds the sensor's performance, decide whether to make changes, or to settle for a compromise exposure and/or rely on post-processing.

7. METER & EXPOSE
Use the appropriate metering mode, adjusting up or down if necessary.

8. REVIEW
Review the result on the screen. If it needs improving, re-shoot if appropriate.

FAST-TRACK &
FOOLPROOF

11

Technical

The Twelve

Style

Post-processing

Reference

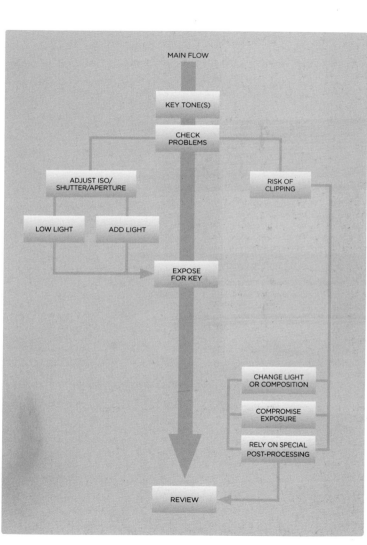

The Key Decisions

Let's expand on this bare-bones summary from the last pages.

1. Settings

Before you shoot, have camera settings exactly as you need them:

• Metering mode: Choose between auto or manual, depending on your preference.

• File format: Raw, TIFF, or JPEG, or a combination such as Raw + JPEG.

• Instant review turned on after each shot (this is just a recommendation).

• Highlight clipping warning: Some people find this distracting, but others value it as a rapid aid to controlling one of digital photography's special exposure problems.

• Histogram readily accessible: With some camera manufacturers this is overlaid on the review image, which is certainly distracting, but it is useful to have available at one click.

2. Metering method

Know exactly how your chosen metering mode behaves. Most cameras offer a choice between, say, average center-weighted, smart predictive, and spot. Some camera models use very smart methods, such as comparing the distribution of tones with a large bank of previously analyzed images. If you choose to rely on an advanced system, make sure that you know how consistently it behaves for you. If it over- or underexposes for certain kinds of composition and lighting that you favor,

simply be aware, so that you can adjust with confidence. If you use a simple method, still know how it behaves in different situations. You may need to make adjustments at any time, which is why this is returned to at point 7.

3. What do you want?

Know clearly what the photograph is about—what caught your eye, what attracts you about the shot, and what you want to convey. Have in your mind's eye how bright it should be overall, and how the distribution of brightness should look. Naturally, this is the million-dollar question.

4. Likely problems

Scan the scene for exposure issues. Think about what is in front of the camera before letting the metering system loose on it. For example, is there a major hotspot that is likely to blow out? Does it matter if it does? Most problems occur because the dynamic range of the scene is greater than the sensor can capture in one exposure.

FAST-TRACK & FOOLPROOF

13

Technical

The Twelve

Style

Post-processing

Reference

5. Key tones

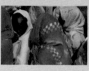

Decide on the important subject (or subjects) and how bright it (or they) should be. In a portrait, this is likely to be the face, but it ultimately depends on your creative judgment. If it is a face, is it Caucasian, or East Asian (which needs to be lighter than mid-tone) or black, (which needs to be darker than mid-tone)? The key tone may be only a part of the key subject, or in some circumstances it may be another part of the scene, such as a background.

6. Is clipping likely? Is there a conflict?

If there's a conflict between points 4 and 5, work out how to resolve it. The choice is between changing the light or the composition, or accepting either a compromise in the exposure, relying on special post-processing, or both. For example, if a portrait is backlit and the background has to be heavily clipped for the exposure to be right for the face, you might want to add foreground shadow fill, accept a clipped background, or change the composition. As another example, if there is a small bright hotspot doing nothing special for a shot, you might re-frame to crop it out. A compromise exposure means accepting either shadows that are too dark or overexposed highlights, which may be perfectly acceptable, depending on the effect you want (see point 3). The third alternative, which can sometimes

be combined with a compromise exposure, is to rely on special post-processing techniques, such as exposure blending or even HDR (High Dynamic Range), which might in turn call for multiple exposures that can be digitally blended.

7. Apply metering

This depends on your preferred way of working with the camera settings. One method is to use a dedicated metering technique to measure and set the key tones, such as spot-metering, to measure an area precisely. Another is to decide from experience how much more or less exposure from the default is needed and to set it accordingly, typically by using an exposure compensation button.

8. Review, reshoot

Review on the camera screen, adjust, and re-shoot if necessary— and if there's time. This is all about the kind of shooting you are doing and the situation you are in. If the action is fast and either continuous or unpredictable, it would be a very bad idea to check the camera screen after each shot. If you are shooting a landscape as the sun slowly sinks and you have plenty of time, you can afford to check everything thoroughly and shoot variations.

Decision Flow

In digital photography there are three areas involved in exposure. These are your shooting technique, your personal style, and post-processing, and the main chapters of this book follow this breakdown.

The last area, post-processing, may at first seem a little odd, given that the whole subject revolves around the moment of exposure. Yet this very digital stage is linked intimately to the moment of shooting in two important ways. One is the practice of shooting in Raw format, which is always recommended and allows, among other things, for the exposure to be revisited. The second is that many of the newer, more advanced processing techniques affect the immediate exposure decisions, allowing you to shoot at a setting that otherwise you might not think worthwhile.

Nevertheless, the straightforward technique, style, then post-processing route is not necessarily the order in which exposure decisions are made. On the previous pages we looked at all the important exposure decisions you need to make, some of them at leisure earlier and some just a fraction of a second before shooting. Here, I've put together the full Decision Flow in what is usually the most logical sequence. If it looks daunting, that's only because I have broken down the process of making an exposure into steps that, in reality, are close to instantaneous.

It begins with having all the camera settings and the metering mode as you need them, and this may vary according to the lighting situation. For instance, if I know that I'm likely to encounter low lighting and I'm shooting handheld, I'll switch the camera's auto ISO on, with an upper-limit shutter speed based on the lens I'm going to need. However, if it's a tripod situation, I'll switch it off.

Then comes the all-important decision of knowing what you want from the scene, which is always personal and could be considered an underlying condition as much as a decision.

Next we have the twin scene-critical decisions that establish everything to follow. I've put them side by side because they are of equal importance, and even if one precedes the other by a fraction they are right next to each other in time sequence. One involves deciding on the most important area of tone (or tones) in the scene. The other is damage control, scanning the scene and situation rapidly for likely problems. A neatly separated issue, at least as far as exposure is concerned, is the quantity of light. Once that is dealt with, the other major issues are to do with dynamic range and the danger of clipping.

In the next chapter we'll look at dynamic range, and the three conditions that determine whether there is likely to be a problem. With a low scene dynamic range, there never is a problem; if the scene dynamic range just fits that of the sensor then there may be no issues, but that depends on where you locate the key tone; if the dynamic range is high, there certainly will be a clipping issue.

So, if there's no conflict between choosing the key tone and clipping, you simply expose for the key. If there is a conflict, there are three solutions. One is to accept a compromise in the exposure and settle for the best that's possible. Another is to make changes, which usually means to the light or to the composition. A third, newly digital, is to anticipate special post-processing techniques, many of which lead to a recovery of tones.

Finally, review the shot if you have time, and if it's less than perfect, adjust and shoot another frame—again, if you have time.

FAST-TRACK &
FOOLPROOF

15

Technical

The Twelve

Style

Post-processing

Reference

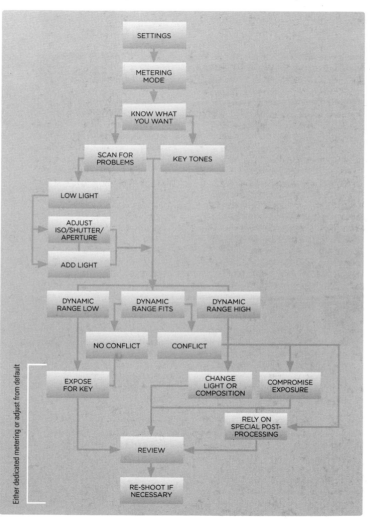

SETTINGS

METERING MODE

KNOW WHAT YOU WANT

SCAN FOR PROBLEMS

KEY TONES

LOW LIGHT

ADJUST ISO/SHUTTER/APERTURE

ADD LIGHT

DYNAMIC RANGE LOW

DYNAMIC RANGE FITS

DYNAMIC RANGE HIGH

NO CONFLICT

CONFLICT

EXPOSE FOR KEY

CHANGE LIGHT OR COMPOSITION

COMPROMISE EXPOSURE

RELY ON SPECIAL POST-PROCESSING

REVIEW

RE-SHOOT IF NECESSARY

Either dedicated metering or adjust from default

Think Brightness, Exposure

I added this at the last minute, when, after talking at length to a number of readers, I realized that not everyone is completely comfortable switching between brightness, exposure, and *f*-stops.

This is really to do with working method, and yes, it does vary. Photographers have their own idiosyncrasies, their own ways of thinking about light and exposure, and this applies especially to professionals, who have had to work out foolproof methods and have honed these with constant experience.

However, whichever way you package the decision-making process, it ultimately rests on knowing what camera settings will get you what results. The simplest, most universally intelligible unit is the stop. You can make life more complicated by talking about EV (Exposure Value) or, worse still in my opinion, Zones, but stops are very, very simple: one

step up or down on the aperture or the shutter speed.

Nor is it complicated to relate stops to brightness, and in most circumstances it is not necessary to be obsessively accurate. The chart here is the basic translation, and it does not pretend to be precise. But it is sufficient for most purposes. We are, after all, taking photographs at this point, not tweaking them in Photoshop.

The simplest way, it seems to me, to think about brightness is as a percentage. 0% is black, 100% total white, and 50% is in the middle. Later, we'll look at gray cards and why they are 18% reflectance, but interesting though this may be if you have the time to think about it, 50% is a lot more intuitive. And it is also how a mid-tone measures on the computer in Photoshop's HSB, or whichever processing software you use.

Measuring brightness

Here, and throughout the book, I use brightness as the basic measurement of the amount of light (see page 22, *Exposure terms*). The way of measuring it is the same as in Photoshop's HSB: total black is 0%, mid-brightness is 50%, and total white 100%. This is worth mentioning because there are several light measurements, and it's easy to get bogged

down in the minutiae when the real business at hand is practical photography. The diagram here shows approximately how it relates to *f*-stops. Most exposure decisions do not need a high degree of precision, but it helps, at least to my mind, to be able to think simultaneously in terms of relative brightness and in the stops needed to achieve it.

f Stops from Average			-2	-1			+1	+2	+3							
Brightness %	0	10	20	25	30	33	40	50	60	66	70	75	80	90	100	
Levels 0–255	0	–	25		50		75	100	128		150		175	200	225	255

FAST-TRACK & FOOLPROOF

17

Technical

The Twelve

Style

Post-processing

Reference

At its absolute crudest, you could say that a little bit lighter is half a stop, quite a bit lighter is one stop, significantly lighter two stops, and so on. If it seems that I'm promoting sloppy measurement here, yet being almost compulsive in other sections of the book, it's because somewhere here I need to stress the importance of getting things in proportion. If you have the time and the camera is on a tripod, you can measure away to your heart's content, get the readings down to ⅓ of a stop, and have the plan mapped out

with total precision. But most photography is not like that, and if you are in the street and have seconds to work it out, what's needed is a fast and basically accurate decision.

I cannot recommend too strongly the simple ability to look at a scene, see blocks of roughly similar brightness, know intuitively what that brightness is, and how that translates into stops. With practice, it's easy, and maybe you do this already, but if not, now is the time to start!

QUICK DECISIONS

Reducing this image to the essentials, I see the sea and sky as one tone block, the white shirts of the men that are in shadow as another, the two sunlit white shirts as a third, and lastly the black sand. To put this in perspective, I probably spent a couple of seconds thinking about the exposure.

The quick decision process went as follows:
1. Watch out for clipping on the bright, white shirts; keep as bright as possible.
2. Sea and sky all more or less the same; fairly bright.
3. Shadowed white shirts not so important; let fall wherever on the brightness scale.
4. Black sand not important; will in any event be very dark.

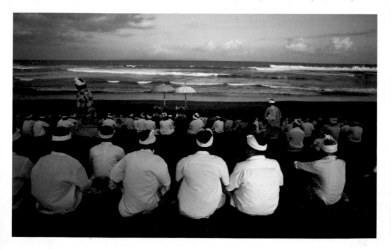

TECHNICAL

So simple. So crucial. Getting the exposure right remains the greatest concern for a large majority of photographers. Now, in digital photography, it is more important than ever: not only because digital sensors are essentially unforgiving in their response to over- and underexposure, but because digital techniques offer greater opportunities for perfecting exposure.

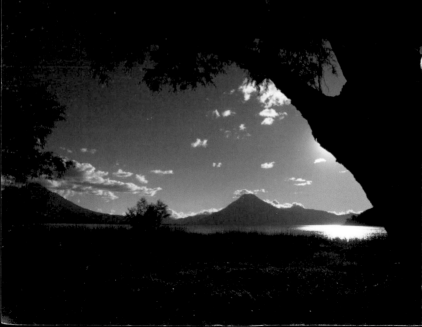

The limitations are more than offset by possibilities, and the two combined make exposure in digital photography a rich and rewarding subject. Perfecting exposure calls on three areas of photography— technical, taste, and post-processing. Here we begin with the technical base. We need to look at how a camera sensor works, the all-important issue of dynamic range (of the sensor and of the scene), and the details of how light and exposure are measured. Underlying all of this is the assumption that there exists a kind of ideal exposure setting for any picture. This is true up to a point, but as we'll see later in this book, it has to be tempered with your own creative decisions as a photographer.

One reason for my writing this book is that with digital photography there is a great deal to consider in the realm of exposure, more so than with film because of the vagaries of digital capture and because of the many settings and adjustments that are possible. With all this potential complexity, the whole subject of exposure seems in need of clear thinking. Another reason, frankly, is that I get bewildered when I look at much of the advice peddled on exposure, especially online. Much of it comes from people who are not actually photographers, at least not in the way that I understand professional photography. There is a growing number of experts on imaging software and on camera

engineering, but this seems to me to be the wrong direction from which to approach the subject. Surely it's the photography that should come first? Purpose, ideas, vision, the ability to shoot worthwhile subjects in a striking way, these kinds of things. From this point of view—my point of view—exposure is less about twiddling knobs and pressing buttons than about managing light and knowing what you want from an image.

It returns to the intriguing paradox of a decision that in the end affects just three simple settings—aperture, shutter speed, and sensitivity—and yet is endlessly complex.

HIGHLIGHTS VS. SHADOWS
Getting the sky tones right was key in this Guatemalan scene, but equally important was keeping the foreground mid-shadows on the grass with just a hint of detail.

DARFUR SCENE
Colorful dress and dark skin tones were the key to this shot of Sudanese women in the troubled Darfur region.

Light on the Sensor

As almost everything to do with exposure is in some way connected to the sensor, it pays to have a good understanding of what goes on inside. The question is, how much do you need to know?

Given that we're photographers rather than engineers (well, a few might be both), and that sensor design and manufacture involves complex technology, a full understanding isn't possible. This is a basic issue that affects much of post-film photography—working digitally now means we're dependent on software, firmware, and hardware that is not at all obvious in what it actually does. And apart from the complexity of the engineering, camera manufacturers are justifiably very secretive about what goes on under the hood.

They need to protect unique research, and also not draw attention to deficiencies, which there always are. Here I'll attempt to cover just what is needed and relevant, but at the same time posting warnings.

The basic unit of the sensor is the photosite, each one of which collects the light for one pixel. The density of photosites on a sensor is measured as pixel pitch—the distance between the center of one pixel to its neighbor—and the higher the pitch, the better the resolution. Unfortunately noise, which we'll deal with later, is worse from sensors with small photosites, so image quality involves a compromise between density and the area of each photosite. This makes small camera design difficult.

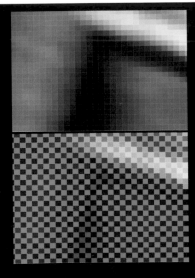

THE MOSAIC SYSTEM

A tiny segment of this image of the French Tricolor shows individual pixels, each from one photosite. The recorded image is in monochrome, not color, but overlaying the sensor is a three-colored mosaic Bayer filter. The software's job when demosaicing is to interpolate accurately from the pattern of red, green, and blue, at different brightnesses, the original colors of the scene.

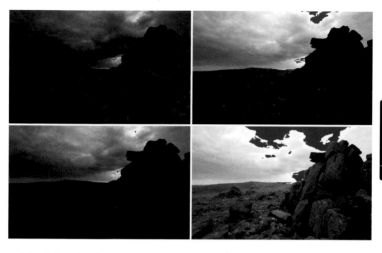

Fast-track & Foolproof

TECHNICAL

21

The Twelve

Style

Post-processing

Reference

When light strikes the sensor, it is stored as an electrical charge in each photosite. One photon excites one electron, and this is read as voltage. The next step, involving an analog-to-digital converter (ADC), is to convert the voltage into digital data. As this is all monochrome information, in order to get color a mosaic filter is fitted in front of the sensor, with a pattern of red, green, and blue (there are twice as many green as red or blue because of the eye's greater sensitivity and resolving power in green wavelengths). As two-thirds of the real color information from the scene is lost in this way, the camera's processor has to interpolate it in a procedure called "demosaicing."

The different digital values for each pixel, taken all together for the area of the sensor, can then be displayed as an image. A normal computer screen can display 256 distinct tones from black to white. In between taking the basic raw image data and delivering a

SHADOW AND HIGHLIGHT CLIPPING
Clipping, shown here in the way an image is displayed on the computer when processing the Raw file, happens suddenly, not gradually, with changes of exposure. Each exposure here is one stop apart. Blue shows as completely featureless black, with red as completely featureless white.

digital image onto the camera's memory card, there is even more processing, aimed at producing a generally pleasing result.

Yet one of the most important things to bear in mind with sensors is that they respond to light in a *linear* way, meaning they fill up with an electrical charge in perfect proportion to the amount of light. On a graph this looks like a straight line, so what's the issue? Well, our own visual system is much more sophisticated and accommodating, and we don't see bright highlights and deep shadows disappearing abruptly. Our response—and that of film—is non-linear, and that helps us see detail in a wider range of tones.

Exposure Terms

At this point, I think it's useful to provide a basic glossary of the most common words and terms used in the business of exposure. In particular, there are several terms used to describe the quantities of light that seem at first glance to be very similar, yet they have important differences.

Beware that on the internet and even in some software interfaces, these terms can be misused. Software manufacturers need to find terms to describe what various sliders and controls do, even though some of these are quite complex. They usually reach for the nearest intelligible word, even if it really means something different. Lightness is one example. It really means the way the eye and brain judge the reflecting qualities of a surface. In other words, a piece of white card is lighter than a piece of gray card. In software processing, however, it usually refers to an adjustment that either adds white or black—a very different matter and a different result.

LUMINANCE
The amount of light (strictly speaking, luminous intensity) that reaches the eye or sensor from a surface or a light source. Essentially, the measurable quantity that comes closest to brightness, measured in candelas per square meter (cd/m2).

ILLUMINANCE
The luminous power from a light source falling on a surface, per unit area, which is measured in lux.

REFLECTANCE
The proportion of light falling on a surface that is emitted by it. It is a measurable, physical quantity. Another way of looking at it is the effectiveness of a surface to pass on the light falling on it. The difference between a pure white surface and a pure black surface in the same lighting is no more than about 30:1, or 4 stops. If that seems surprisingly little, it merely emphasizes how the *amount* of light falling on different parts of a scene is much more important. 18% reflectance looks like 50% to the eye, due to the non-linear way we perceive, hence the 18% reflectance used for a Gray Card (see pages 48–49).

BRIGHTNESS
This is perceived luminance, so it is therefore subjective and not precisely measurable. It is the most common word we use to describe the amount of light we see.

Psychology of perception

Light falling on the eye or the camera sensor is an essential quantity to understand, but what gets in the way is the psychology of perception. Our eyes and brain process the light information very differently and more intelligently than a camera sensor. So, luminance, which is the amount of light that a sensor faithfully records is a culmination of the physical and the perceived.

Physical, measurable quantity	Perceived, subjective quantity
• Luminance	• Brightness
• Reflectance	• Lightness

Fast-track & Foolproof

TECHNICAL

23

The Twelve

Style

Post-processing

Reference

LIGHTNESS

This is the perceived reflectance. It is subjective, like brightness, and the attempt by the eye and brain to judge how well a surface reflects light.

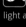

VALUE

When talking about light measurement, value equals brightness.

EXPOSURE

In a camera, this is the amount of light allowed to fall on the sensor.

OVER- AND UNDEREXPOSURE

These terms are often used vaguely and subjectively to mean more than (over-) and less than (under-) ideal.

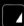

HIGHLIGHTS

The upper end of the tonal scale, either in the scene or in the image. There is no precise definition of the cut-off point. Some people understand the term to mean the upper quarter of the range, while others believe it means the top few percent only. Clipped highlights are those at the very top that have been completely overexposed.

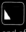

SHADOWS

As with highlights but at the opposite end of the scale. It is a word that varies in use.

CLIPPING

Total loss of information in a pixel because of extreme over- or underexposure.

BLACK POINT

In a digital image, the point on the lower end of the tonal scale that is completely black—0 on the scale from 0–255. When processing a digital photograph, you can choose where this point should be.

WHITE POINT

In a digital image, the point on the upper end of the tonal scale that is completely white—255 on the scale from 0–255. When processing a digital photograph, you can choose where this point should be.

DYNAMIC RANGE

The ratio between the maximum and minimum luminance values, in a scene or in an image.

CONTRAST AND CONTRASTY

Often used interchangeably with "dynamic range," though it does not necessarily mean the same thing. However, it did in the days of film, hence the confusion. Contrast is the ratio between high and low luminance values, but does not necessarily involve the entire tonal range. Commonly, it refers to the ratio excluding top highlights and lowest shadows.

KEY

There are two meanings here. One refers to which part of the brightness range is being used in an image, thus high-key or low-key. The other refers to a tonal area (or zone) of special importance.

Exposure and Noise

Noise is the digital equivalent of film grain, but without any redeeming qualities. I make that qualification because grain in a film image can add a structural texture that some people find pleasing. Digital noise, however, only detracts from an image, and it's as well to be cautious when comparing these two very different effects.

As in sound, which is where the word comes from, image noise is a sampling error. The sensor collects photons, but as photons arrive irregularly, the fewer there are ,the greater the sampling error. This is why noise is at its worst in dark tones. And at its worst, it overwhelms image detail. Look at a noisy image at 100% and you will have difficulty in distinguishing real detail from noise. At this point all you can rely on is your perception, using a mixture of knowledge and imagination. However, if you examine areas with evidently little or no detail, like a typical sky or a piece of plain cloth, or indeed any area that is obviously out of focus, any noise will stand out very clearly as there is no detail to compete with. On the other hand, if there is an area full of small detail almost down to pixel level, such as dense vegetation, it may be hard to see the noise above the detail.

The lesson here is that noise appears at its worst in dark tones and smooth areas. Now, so long as the dark tones remain dark, the sheer lack of visibility will keep much of the noise in a noisy image hidden. Problems multiply when you take any action to open up the shadows. If you increase the exposure, you allow the sensor to collect more photons, which is good, but the construction of the sensor itself is never perfect and at long exposures these imperfections become more obvious. This is known as dark current or dark noise, and is consistent for any one sensor at

the same temperature. Most of it can be removed by the simple method of making another equal exposure without any light, and subtracting the noise generated from the actual image in the first exposure.

Increasing the sensitivity settings of the sensor, by raising the ISO setting, has the greatest visible effect. New sensor designs and demosaicing methods have concentrated on this area, and some high-end cameras are noticeably more usable in low light than others. Also, improved noise performance is one way to increase the dynamic range of a camera, as we'll now see.

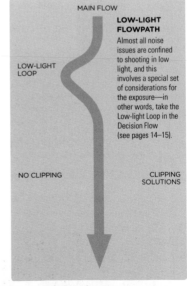

MAIN FLOW

LOW-LIGHT FLOWPATH
Almost all noise issues are confined to shooting in low light, and this involves a special set of considerations for the exposure—in other words, take the Low-light Loop in the Decision Flow (see pages 14–15).

LOW-LIGHT LOOP

NO CLIPPING

CLIPPING SOLUTIONS

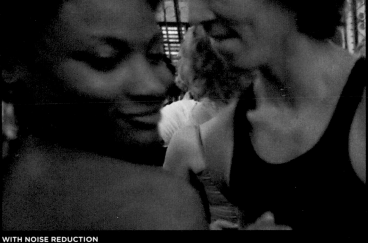

WITH NOISE REDUCTION

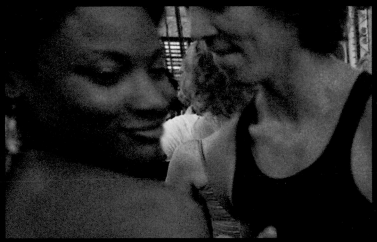

WITHOUT NOISE REDUCTION

Here are details from a shot taken at high ISO from a camera with excellent noise suppression—a Nikon D3. The ISO setting is a remarkably high 25,600, shown here with no noise removal attempted by the Raw conversion software, and with a strong 70% removal setting.

Fast-track & Foolproof

TECHNICAL

25

The Twelve

Style

Post-processing

Reference

Sensor Dynamic Range

Nothing beats the combination of a camera sensor and scene that are perfectly matched. In this argument, the technical follows the philosophical, because the ideal for any imaging system is that the equipment (the camera in this case) uses 100 percent of its capabilities to record the scene in front of it. Anything else means a loss of quality somewhere and in some way.

There are many software techniques for recovering, adjusting, improving, and adding to the captured image, and in Chapter 3 we'll be making full use of them, but it's important to remember that there's always a price to pay. Yes, algorithms that pull back lost highlights from the brink, fill in shadow detail, and expand the range do perform minor miracles, but as we'll see, they always involve subtle losses, and sometimes major penalties. As a rule of thumb, a good DSLR these days has a dynamic range of around 10 to 11 stops, or between around 1,000:1 and 2,000:1. This means that a single frame can capture brightness levels 10 or 11 stops apart without clipping. Dynamic range for a sensor depends on two things principally—which is to say, two limits. One of these is the capacity of each photosite to hold electrons, called *full well capacity*. The larger the area of the photosite, the better this will be, and modern high-end DSLRs have capacities in the range of 7,000–10,000 electrons. At the other end, the limit is set by noise, and the point at which noise cannot be distinguished from real detail is called the *noise floor*. Modern DSLRs have noise floors of around 4–8 electrons. Divide the full well capacity by the noise floor and you get the dynamic range.

For all die-hard film enthusiasts, I'm afraid this is quite a lot better than the dynamic range of slide film, mainly because of the loss

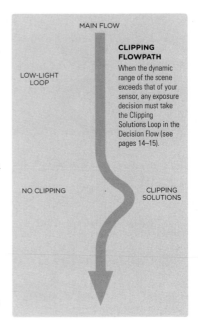

MAIN FLOW

LOW-LIGHT LOOP

CLIPPING FLOWPATH
When the dynamic range of the scene exceeds that of your sensor, any exposure decision must take the Clipping Solutions Loop in the Decision Flow (see pages 14–15).

NO CLIPPING

CLIPPING SOLUTIONS

of shadow detail to grain. Of course, film has other qualities, and this poorer performance on dynamic range is tempered by two things in particular. One is the more pleasing roll-off in the highlights, which we'll look at over the following pages, and the other is that grain clusters have the potential to be, well, more *likable* than digital noise. This is hugely subjective, but generations of photographers have come to accept that grain can, under certain conditions, be accepted as part of the texture of the image. Noise is unlikely ever to be tolerated in the same way.

Dynamic range

The dynamic range of a sensor is the difference between the full well capacity (the maximum number of electrons each photosite can hold) and the noise floor (the point at which noise swamps all subject detail). The noise floor is strictly set by the read noise, but shot noise, which is associated with the random arrival of photons, is related to the signal, and so in practice reduces the dynamic range further.

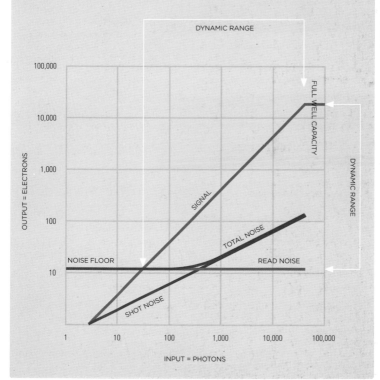

Highlight Clipping and Roll-Off

Losing image detail is the big issue in exposure, and comes before all the subtleties of what happens to the middle tones. Visually, losing detail in the highlights is always more obvious, and looks worse to most people than losing it in the shadows. There is also a higher risk of it occurring.

The usual term for it in digital photography is highlight clipping. This is a very apt expression, because one of the worst things about overexposure with a digital camera is that when the highlights go, they go suddenly, as if they've been cut or clipped. Highlight clipping is worth special attention.

At this very top end of the register, digital highlights can behave in unusual ways that don't fit with the way we see, and which is visually not particularly pleasant. (I realize this is subjective, and under some circumstances

it's possible to make creative use of it, but we'll come to that in the next chapter, on pages 98–101). If there is overexposure, the highlights tend to clip with a fairly sharp and obvious break that is quite different and harsher than the way film would record the same image. It is also harsher than the way we perceive it. The S-curve that used to be familiar to anyone shooting film is a good diagrammatic way of showing the response of not just film, but also the eye and brain, as I

POST-PROCESSING

Clipping is inevitable when shooting into the sun in a single frame, but the hard edges are a particular and unpleasant feature of digital capture. An unwanted side-effect is the different clipping points for each channel, which gives color banding. In-camera processing can help, but this varies from model to model. Shown here is the original file and a Raw file, post-processed with 100% highlight recovery.

AS SHOT 100% RECOVERY

touched on earlier. This is also the curve that has to be applied in the camera to a Raw linear digital image, in order to make it look acceptable. With film, the top end of the curve that slopes away to become flatter and flatter is called the *shoulder*, while the lower end is the *toe*.

Digitally, it's more common to talk about roll-off, which means essentially the same thing, that in the highlights the tones grade gently away rather than going abruptly to white. In-camera processing does its best to make this happen, and much later, when you process Raw images (if you shoot Raw), there are procedures for applying extra roll-off. However, there are limits to how successful this can be, because when pixels on the sensor have reacted to so much light that they have reached full well capacity, that's it—they are

blown and there simply is no visual information there any more. Additionally, because the three color channels of red, green, and blue often clip at different exposure points, there may be odd color fringes.

ROLL-OFF

The effect of roll-off is subtle but important, illustrated here by switching off and on the default curve applied by one Raw converter. This is similar to part of the processing applied in-camera to non-Raw files; a curve that lifts the shoulder where the lights (the high values just below highlights) are. The area in question is a detail of the entire image, a bright white cloud. Note that even though the default curve actually introduces some clipping by lifting some of the highlights, it nevertheless softens the transition from lights into those highlights. Without the curve there is a noticeable edge to the white, with a color cast due to the three channels reacting unequally.

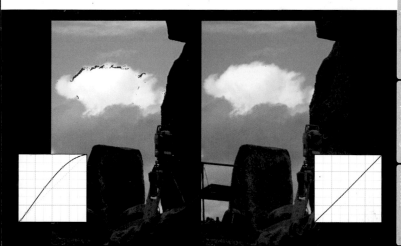

Scene Dynamic Range

One of the key questions in exposure is this: is the dynamic range of the camera enough for the scene? Put very simply, does it fit? If it does, then life becomes much simpler, and there should be no reason for over- or underexposing, and there should be no reason for clipping. If, on the other hand, the camera's dynamic range is too small, then you have a potential problem, and in the decision flow, this means taking the clipping solutions route.

The dynamic range of a scene is the product of two things—the light falling on it and the light reflected from different surfaces. However, of these two, the light is much more important. The difference in range between a white card and a black card is no more than 30:1, so it contributes relatively little when the dynamic range of some normal scenes can be as high as 10,000:1 or 14 stops. Most of this comes from the lighting. Naked lights create a higher range than diffuse lights because less of their illumination leaks into the shaded parts of a scene, so you can expect the range to be high under an intense sun on a clear day, and lower under clouds or in haze.

The scene's dynamic range also depends on how you choose to shoot. Shooting toward the light gives a higher dynamic range than shooting away from it. Also, if the light source itself is included in the frame, the dynamic range is *always* high. I've been cautious about putting numbers on all this because the definitions of low and high are largely a matter of judgment, and are, for practical reasons, related to the camera's own range. If

the range of the camera's sensor matches that of the scene—say, around ten stops—there's a reasonable case for calling it average or normal. Beyond this, there are degrees of high dynamic range—medium-high and true high. Of the two, true high dynamic range needs HDRI techniques, while medium-high dynamic range (perhaps two or three stops beyond the camera's ability) can be dealt with using less-specialized methods.

What contributes to...

LOW DYNAMIC RANGE
1. Completely diffuse lighting.
2. Thick atmosphere (such as fog, smoke, or dust).
3. Shooting away from the light source.
4. Similar-toned surfaces.

MEDIUM HIGH DYNAMIC RANGE
1. Intense light source casting sharp shadows.
2. Strong relief to give strong shadows.
3. Backlighting.
4. Light and dark surfaces together.

TRUE HIGH DYNAMIC RANGE
1. Light source, or its strong reflection, in the frame.
2. Very well protected deep shadows.
3. Scene divided into brightly lit/hardly lit segments.

EFFECT OF FRAMING

Mountains in cloud have, like any strongly atmospheric weather conditions, a low dynamic range. Note, however, that the nearer cliff-side, with little cloud or mist between it and the camera, takes the dark values down to give a scene that is not much less than the sensor's range. The boxed inset area has a much lower dynamic range. This underlines the all-important issue of framing—how you compose the scene will often have the biggest effect of all on dynamic range.

Scene Dynamic Range

BRIGHT CONDITIONS

Bright late afternoon sunlight in exceptionally clear, crisp weather, coupled with light surfaces (like the poster and the horse and carriage) and dense shadows, give a dynamic range that is predictably higher than the camera sensor. The histogram crushes up against the left and right edges of the scale.

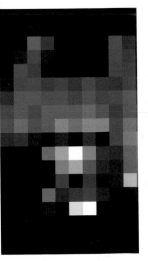

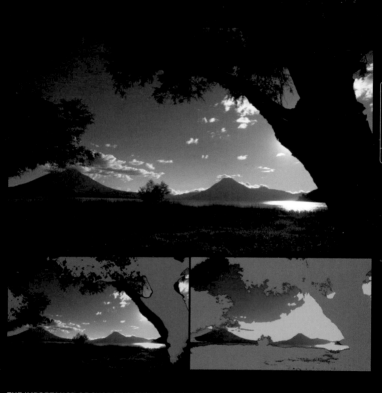

Fast-track & Foolproof

TECHNICAL

33

The Twelve

Style

Post-processing

Reference

THE IMPORTANCE OF SHADOWS AND HIGHLIGHTS

Scenes with a high dynamic range place greater importance on shadows and highlights in the sense of how to treat them. This very high-range scene in Guatemala, probably with a dynamic range of about 13 stops (I didn't measure it and it is strongly clipped), has very high values in the sun's reflection in the lake, and there would have been another two stops beyond this had I included the sun in the shot. Hiding the sun behind the tree was obviously one solution to keep the range down. The exceptionally clear air meant little diffusion, and so dense shadows. When shooting, a glance

at a situation like this shows that a more or less average exposure will put the reflection in the lake and the bulk of the tree trunk out of range. There is no remedy in a single shot but to let the first go to flare and the second go to a silhouette. The medium shadows and highlights, however, become important areas to consider—that is, the grass and leaves on the one hand, and the white clouds and sky near the sun on the other. How you want to treat them becomes a matter for consideration—and for personal taste. See Chapter 4, Style, for more on this.

Contrast, High and Low

Contrast in photography has come in for some re-definition recently, or at least a closer and more accurate look. This is mainly because of a hangover from the days of film, when *contrast* was used to describe the performance of film and paper emulsions.

Used in a general way, as in a *high-contrast scene*, it is the equivalent of dynamic range, but sometimes we mean different things. You can increase the contrast of an image, for example, *without* changing the dynamic range.

This calls for a closer explanation. Looking at a typical response curve, the contrast is actually well described by the angle of the slope on the middle section. The steeper it is, the more contrasty the image. This is why the word gamma is often used to describe contrast. If the slope is shallow—less than 45° on a standard log curve diagram—the contrast will look low, but if the slope is steeper, the contrast will be high. The reason we talk about the middle section of the curve

is that this is where the mid-tones are, and therefore most of the important information.

As we'll see in Chapter 5, in processing or post-production you can raise or lower the angle of the slope in order to alter the contrast. However, if you do this in Curves, just changing the shape by moving two points as shown here, you change the contrast but *not* the dynamic range, as the end-points of the scale stay where they are. This is why it becomes a little dangerous to talk about contrast and dynamic range as if they are always the same thing.

Moreover, it's important to be clear about what *area* of the image we're talking about, because contrast can vary *spatially*. This has become an issue since the invention of local tone-mapping—a digital processing technique now widely used, and described in Chapter 5. At one extreme is global contrast, meaning across the entire image. At the other is local contrast, across small segments of the

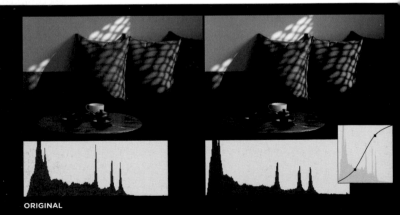

ORIGINAL

image. On the very smallest scale of all, across one or two pixels only, contrast affects sharpness—digital sharpening, in fact, means increasing the contrast between pixels. The terminology for this is still not quite universal, but it's valid and useful to talk about large-scale, mid-scale, and small-scale contrast. The images here show the differences.

DIFFERENT SCALES OF CONTRAST

To demonstrate the differences between global and local contrast, I must step into processing so we can make direct comparisons on a single image. The dynamic range in this scene remains unchanged. The scene as shot shows a histogram that fills the range, but with the bulk of the tones off-centered toward dark. Applying a standard contrast-increasing S-curve gives deeper shadows and brighter highlights, but without clipping, as you would expect. The effect is more contrasty, and the histogram shows the bulk of tones "stretched" outward. In comparison, when a reverse S-curve is applied for a lower contrast, the bulk of the tones are more compressed. A third kind, which is more localized in its effect, is created by using a local-contrast control (Shadows/Highlights in Photoshop).

Fast-track & Foolproof

TECHNICAL

35

The Twelve

Style

Post-processing

Reference

Contrast and gamma

Contrast and gamma are related, and even sometimes treated as identical, but offer potential for confusion. Gamma is a difficult concept to grasp because it is used to refer to different things in imagery and electronics. It is a measurement that relates input to output, and so in the language of monitors and color it is a mathematical formula that relates the voltage input to the brightness output on the screen. This seems a long way from what we are discussing here, but it's important to establish that very specific use, as it crops up when you calibrate your display screen. Gamma encoding is necessary when transmitting image signals in order to give a realistic-looking brightness and contrast. For this reason, gamma is often used interchangeably with contrast. The higher the gamma, the steeper the slope, and the more contrasty the image appears to be.

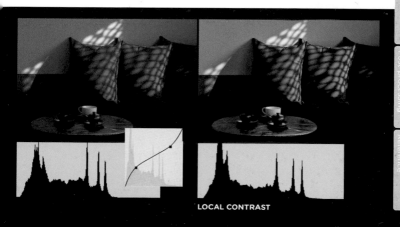

LOCAL CONTRAST

Metering Modes—Basic and Weighted

For camera manufacturers, metering has a high priority, and there is continuous product improvement as they try to satisfy the needs of every photographer as seamlessly as possible.

For this reason, all SLRs and high-end cameras offer a choice of metering patterns, and while all the development work goes into the smart modes that we'll look at on the following pages, the original basic modes are there for anyone who wants full control.

Naturally they vary from model to model, but the possible choices are these: average, center-weighted, center-circle, and spot. The essential thing to do with any new camera is to learn exactly how these work and what areas of the image are being measured.

Average metering means measuring the entire frame with no bias at all, and is quite rare nowadays. It tends to be confined to top-end professional cameras as one of several options. Its value is the same as for spot-metering—you don't need to guess what fancy adjustments the camera manufacturer has built into the method, because there aren't any. If there is a sliver of bright sky at the top of the frame, that will not be ignored but simply included in the overall measurement.

Center-weighted metering favors the broad center of the frame, and usually excludes the top (when horizontal) to avoid the occasional bright strip of sky in a common composition from affecting the reading. This was the earliest attempt to anticipate how users take pictures, but it's fairly crude by modern standards. Although useful, it is not always easy to find out exactly what the bias is, and this can make it tricky when you want to make fine or very accurate adjustments.

Center-circle metering defines itself. The reading is taken from a circle of a particular diameter, and when this circle is engraved on the focusing screen (though not always, by any means), this can be very useful indeed, similar to a large spot reading. However, cameras with this method may actually be reading a fuzzy version of the circle, with no abrupt cut-off at the edges, and it's important to know this. Some cameras offer different circle diameters, such as 8 mm, 12 mm, 15 mm, or 20 mm. The way to check circle fuzziness is to aim the camera at a scene containing a sharp-edged, high-contrast area.

Spot-metering mimics that of a handheld meter. Only a very small circle, usually between 1% and 2% of the entire area, is measured, which allows you to focus on any detail of the scene. If that happens to be the key detail, you can see how valuable spot-metering can be at times. As with center-circle metering, the limitation is when you cannot see exactly the circle being measured on the focusing screen.

15 MM CENTER-CIRCLE

SPOT SELECTED BEFORE RECOMPOSITION

8 MM CENTER-CIRCLE

CENTER-WEIGHTED

2% SPOT

Fast-track & Foolproof

TECHNICAL

37

The Twelve

Style

Post-processing

Reference

USING THE CHOICE OF METERING

Staying for now with the basic, relatively primitive choices that have been available in SLRs for many years, the differences in a fairly undemanding composition and setting are not great. The larger center-circle takes in a little more of the sky than the smaller center-circle, and the result is a difference of not more than ¼ stop with this scene. Center-weighted metering is well suited to this particular image, as it pays less attention to the brighter sky at the top of the frame. With spot-metering (or partial metering), the center spot is not intended to be used dead center, but rather aimed at a tone in the scene that you identify as key or average. This involves aiming off, locking the exposure (usually by keeping the shutter release half-pressed), and then re-framing your shot.

Metering Modes—Smart and Predictive

The real development work in metering has gone into increasingly sophisticated ways of trying to match the exposure reading to what is actually in the frame, and these go under different names according to the camera manufacturer, including *Matrix*, *Multi-zone*, *Multi-pattern*, *Honeycomb*, *Segment*, and *Evaluative*.

This is a huge challenge. Part of the solution lies in dividing the measurement into various segments. The other part is making some kind of prediction from this pattern of brightness about what is most important in the scene.

At present there are two manufacturer approaches to this problem. One method—described in the most basic terms—involves building a database of all the kinds of photographic composition that people make and working out good exposure settings for each one. Then, the metering pattern in the camera can be compared with this database to find the nearest similar pattern, and a precalculated exposure setting to match that pattern is applied.

The second approach, which can be combined with the first, is content recognition—an imaging science still in

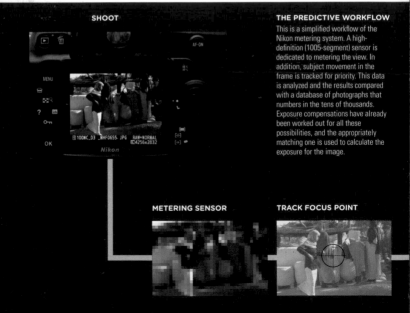

SHOOT

THE PREDICTIVE WORKFLOW

This is a simplified workflow of the Nikon metering system. A high-definition (1005-segment) sensor is dedicated to metering the view. In addition, subject movement in the frame is tracked for priority. This data is analyzed and the results compared with a database of photographs that numbers in the tens of thousands. Exposure compensations have already been worked out for all these possibilities, and the appropriately matching one is used to calculate the exposure for the image.

METERING SENSOR

TRACK FOCUS POINT

Fast-track & Foolproof

TECHNICAL

39

The Twelve

Style

Post-processing

Reference

its infancy. The goal is to recognize subjects in the frame, such as faces and figures. Shape is used, as is focus, on the reasonable assumption that what you choose to focus on is likely to be the key subject in your picture, and possibly even the key tone.

All of this is admirable, and works more and more of the time. As smart metering gets smarter you can expect a smaller rate of failure, which is exactly what camera manufacturers are aiming for. The problem is that the very sophistication of the method makes it harder for the photographer to know what decisions are being taken by the camera's processor, and the camera manufacturers are understandably coy about giving away much information on their hard-won inventions. Also, not everyone likes handing over full control to an algorithm invented by a team of engineers. Going back to the basics of exposure, you still have to decide when it's appropriate to use smart metering and when not—and that means thinking about the exposure in all the ways I'm exploring in this book!

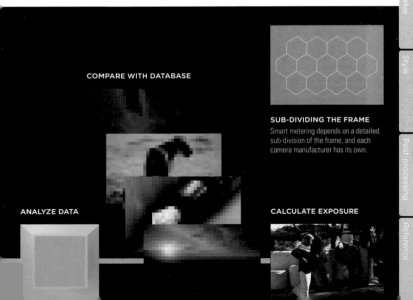

COMPARE WITH DATABASE

SUB-DIVIDING THE FRAME
Smart metering depends on a detailed sub-division of the frame, and each camera manufacturer has its own.

ANALYZE DATA

CALCULATE EXPOSURE

Metering Adjustments

Getting the perfect exposure means rising above total reliance on the camera's metering mode, whichever that is. As the first and all-important step is to know what you want from an image, you have to evaluate the exposure before committing to a metering mode, whether this takes a fraction of a second or it's something you decide at the beginning of a shoot.

Any lighting situation out of the ordinary calls for some adjustment, and there are various ways of doing this. There are two basic choices with an SLR or any camera that allows manual override and a selection of settings. One choice is between manual and auto. The other choice is between metering modes, one of the basic modes or you camera's smart mode. You can use any permutations of these two choices, and it really is a matter of personal working preference.

Let's look at the choice between manual and auto. Setting the camera to manual exposure is straightforward and leaves little room for error, but it does slow things down if you need to switch back to auto quickly for the next shot. It depends on the kind of shooting you are doing and the situation. Once in manual exposure mode, use whatever means your camera has for altering aperture or shutter, and watch the results in the viewfinder exposure display or on an external screen display. Staying with one of the auto exposure modes (typically shutter priority, aperture priority, or programmed), use whatever control your camera has for adjustment/compensation. You may be able to pre-set the exposure compensation to, say, one third of a stop steps or half-stop steps. Check the exposure compensation display in the viewfinder or on one of the external camera screens.

Next, choose between metering modes. The slower, more reliable, and predictable way is to use one of the basic un-weighted modes like center-circle or spot, and measure one of the key tones. This is a good choice if you have time on your hands, such as with a tripod-

ADJUSTING FROM MANUAL OR AUTO

1. With the metering set to auto (in this case, shutter priority), there is no adjustment display by default.

2. Switching to compensation mode displays the exposure scale with an exposure-compensation icon. With this camera, the corresponding button near the shutter release has to remain pressed while the exposure is adjusted with a wheel. The mechanics vary with the camera model.

3. The alternative is to switch from auto to manual mode. The exposure scale is displayed and the shutter speed or aperture controls can be adjusted.

Aim off and re-frame

This is a basic professional technique, especially with basic metering modes. If the key tone is off-center, or even out of frame, aim quickly at that and set the exposure, then quickly move back to the framing you want. Half-depressing the shutter release on most cameras locks the exposure, but check the manual for your camera to confirm this.

Fast-track & Foolproof

TECHNICAL

41

The Twelve

Style

Post-processing

Reference

mounted architectural or landscape shot. A key technique here is to aim at an area of the scene that gives you the measurement you want, then (holding that exposure setting) re-frame for the desired composition.

If you're in a fast-response situation and are thoroughly familiar and at ease with your smart, predictive metering mode, make the adjustments from that. The essential thing here is how well you know the performance of your camera's metering mode, and that's mainly a matter of experience and familiarity. There is more of a risk in this case than with using a basic metering mode, but it tends to be quicker.

2 3

Objectively Correct

Is there such a thing as a measurably correct exposure? This is a good question, because while there is no dispute that the brightness of a photograph can be chosen to suit personal taste, there are also exposures that most people would say were too bright or too dark—in other words, wrong.

The key words here are "most people," and if we're looking for "correctness," we must factor in collective taste. Of course, there needs to be some recognizable image in the first place, which rules out almost total black and almost total white. As it turns out, the best we can say about correctness in exposure and brightness is that there are norms that are accepted, and expected, by most people. This does not prevent anyone from taking off in an unexpected direction and working to an unusual exposure, but that will always be seen as unusual.

The norm in exposure comes from the way we perceive, from what is known of the HVS (Human Visual System). In particular, there are two aspects of exposure that this controls. One is the idea of "average," and the other is the limits of bright and dark. Brightness constancy is one well-known feature of the HVS, in which we see surfaces as keeping the same tone even when the light changes dramatically. A piece of white paper looks the same to us whether we see it in bright sunlight or by candlelight. The HVS adapts automatically to different amounts of light, and this is a form of normalizing. It's not exactly what the camera's metering system does, but it's not far from it in principle.

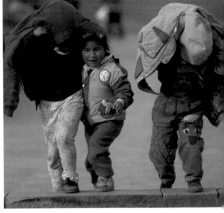

BALANCED IMAGE
This picture of three children has no shadow or highlight areas to speak of, so nothing can be considered "blown."

The limits of bright and dark are handled in a special way by the HVS. The eye adapts rapidly to varying brightness over the small area that it focuses on at any one moment. So, in a scene with a high dynamic range, when our attention flicks from deep shadow to bright highlight, our perception adjusts so that we see the details in each. Our view of the entire scene is built up from flicking over it like this, so we do not have the impression that the highlights and shadows are in any way "blown," blocked-up, or over- or under-exposed. That means that we expect the same from an image, hence the tendency for clipped highlights and pure black shadows to look in a sense "incorrect."

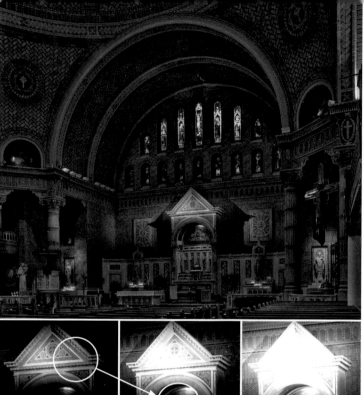

Fast-track
& Foolproof

The Twelve

Style

Post-processing

Reference

HOW THE HVS "EQUALIZES" BRIGHTNESS

There is no completely satisfactory way of reproducing how we perceive, because human vision is a highly active process. By scanning a scene with rapid eye movements called saccades, the Human Visual System rapidly builds up a perception of a scene in which all detail is visible,

reproduced here in a specially processed view of the interior of a church. In practice, the eye flicks from one area to another, so that—as illustrated in the three details—it accommodates for the changes in brightness to 'build' the rapidly remembered scene.

Handheld Meter

If you're really serious about exposure in difficult situations, and don't have to work at the speed of a photojournalist, then a handheld meter is a worthwhile investment.

With the right attachments, such a meter allows precise measurements, calculations dedicated to exposure and luminance, and in particular, the ability to switch from direct to incident light readings. Direct-, or reflected-light, readings are what cameras make, measuring the light entering the camera from the scene. Incident light readings measure the light *falling* on the scene and are unaffected by whether the subject is white, red, gray, or whatever. In other words, if the scene is bathed in the same light (by no means always the case), an exposure based on the light rather than the subjects will, in theory, be completely accurate. The attachment that makes incident readings possible is a translucent white dome that fits over the sensor. This mimics a three-dimensional subject, such as a face. To get a reading hold the meter so that the dome faces the camera and is either right next to the subject or in exactly the same light.

Incident readings are the special province of handheld meters, but by no means the only one. These meters are designed to be adaptable and to offer dedicated help in measuring light, making calculations, and suggesting the exposure. A different attachment, a flat translucent white disc, is intended to measure illuminance. To do this, you aim the disc receptor at the light source (as opposed to aiming the dome toward the camera). There are also various reflected-light attachments available. These have different angles of acceptance, such as 10°, 5°, or down to spot readings of around 1°.

When to use reflected or incident light readings

Because of universal built-in camera metering, reflected light readings are now the default (although some high-end DSLRs include readings from a small incident-light sensor in the calculation). So the practical question is, when is it useful to switch to incident?

1. When you have enough time to take the reading. This is a very practical issue, favoring studio, architecture, and landscape photography.
2. When you can get close enough to the subject to hold the meter nearby.
3. Alternatively, when the light falling on the meter is the same as on the subject.
4. Scenes that are lit by one light source and have a wide range of surfaces with different reflectance, such as landscapes, architecture, paintings, and flat artwork.
5. When you have enough control over the lighting to be able to take advantage of the precise readings, such as in a studio.

Fast-track
& Foolproof

TECHNICAL

45

The Twelve

Style

Post-processing

Reference

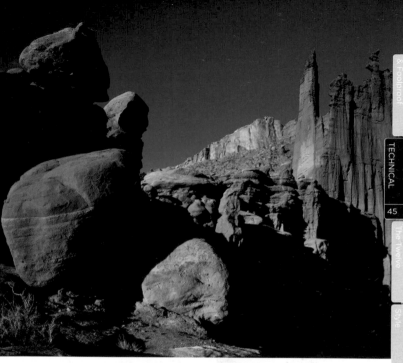

AT-SITE INCIDENT

This late afternoon view of Fisher Towers, Utah, has high contrast, yet a single light source. An incident light reading will work well here. The sunlight falling on the camera position is exactly the same as on the landscape, making it unnecessary to move closer to take the reading.

USING A HANDHELD METER

Replacing the incident light dome with a viewfinder allows reflected light readings similar to using an SLR's center-circle method, but more precisely because there is no shading of sensitivity at the edges of the circle, which will probably be more clearly marked, too.

Gray Card

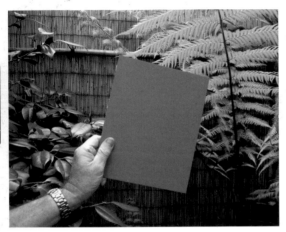

FOR SHOOTING
Using any localized metering mode, such as a center-circle, hold the card in front of the camera and measure it. It is usually easier to switch to manual rather than fiddle one-handed with exposure compensation. Make sure that the card is held in such a way as to catch the light evenly.

Incident-light readings, as we just saw on the previous pages, are an attractive idea when dealing with a wide range of subject surfaces in a single shot. You measure the light alone, so that the different surfaces fall where they will, just as in looking at the scene in a single glance.

Well, there's an equivalent direct reading that you can use with the camera's own meter, and that's a gray card. So long as you buy a card made for photography (there are several manufacturers, including Kodak), you can use it to take the place of a subject for the reading. Gray cards reflect 18% of the light falling on one them, which makes them average, or *mid-tone*. If it puzzles you as to where the 18% figure comes from, this is because our eye and brain perceive in a non-linear way, and 18% reflectance is what *looks like* middle gray. In principle, when you take a reading of the card with the camera's meter,

and photograph it, it should appear in the digital image with a brightness (as in Photoshop's HSB measurement) of 50%.

The other valuable property of a gray card is that, if it is made properly, it will reflect the same 18% across the spectrum. In other words, it will be neutral in color, which makes it doubly useful for calibrating the camera or as a reference for adjusting the color balance later on the computer.

However, there is one slight problem. Due to no good known reason—presumably the camera manufacturers follow a different standard for aesthetic reasons—most camera meters average to 12–13%, not 18%. That's not quite as bad as it sounds, and means a difference of ⅓ to ½ a stop, but it is inconvenient, to say the least. If you use the 18% gray card, the results are likely to be slightly darker.

Fast-track & Foolproof

TECHNICAL

47

The Twelve

Style

Post-processing

Reference

FOR POST-PRODUCTION

An alternative way of using the card, and quicker for shooting, is simply to include it in the shot for reference, not necessarily making readings from it. Later, in processing, it is a valuable standard for adjusting both the brightness (exposure if processing Raw) and color balance, as in these examples. When you import the resulting image into your workflow software—for example Adobe Photoshop Lightroom or Apple Aperture—you will be able to make the necessary color adjustments to the gray card image at the beginning of a sequence and then automatically apply the same results to the following images.

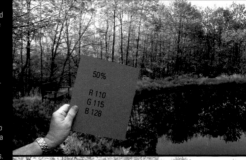

Precautions when using a gray card

1. Make sure the card is evenly lit and facing the camera.
2. Fill the viewfinder frame with the card.
3. Don't allow a shadow (yours or the camera's, for instance) to fall on the card.

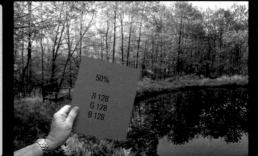

Key Tones, Key Concept

This is a simple but absolutely essential concept, and fortunately one that many photographers follow instinctively. In any photograph, at least one part of the scene is more important than the rest.

Deciding what makes an area important is an entirely personal choice, even though many scenes will invoke similar reactions from different photographers. For example, in the majority of shots that include a person, the face is what attracts the eye most readily, and the larger the area this occupies in the frame, the more likely it is to be the key subject. It's likely, but not guaranteed.

The key area of interest is usually, though not always, the key tone in the scene—the tone that determines the exposure. In Ansel Adams's Zone System, this is the area that would be "placed" in a particular zone, with any other areas that might suffer because of this being adjusted during processing. The

basic logic is hard to escape. You decide what is important in a scene and how bright it should be, and then set the exposure accordingly. The way human perception works, we usually like to see the things that interest us averagely bright, meaning mid-tone, or to put it another way, 18% gray.

Yet this is tempered by what we expect certain things to look like. As we'll see on the following pages, there are certain norms in photographic imagery. Skin tones are expected to look a certain way, as is grass, a blue sky, a white wall, and other things that are so well known that everyone has a rough idea of how bright they should be. As an example, there might be a figure, small in the frame, running across an expanse of grass. The figure's action may be the most important subject, but the key tone is more likely to be the grass itself.

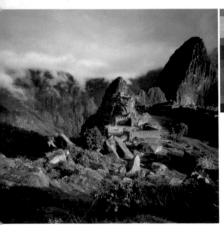

SIMPLE SCENE

In this view of the Inca ruins of Machu Picchu in Peru, the contrast is full, but within the range of the sensor. The key subject is not in any doubt, as it is the sunlit middle ground close to the center of the frame, and although on a small scale the contrast is high, as a local area it is fairly consistent between stone and vegetation. There is no reason for the exposure to be anything other than conventional, middle brightness (50%). By my classification of scene type, this is the simplest, Fits #1.

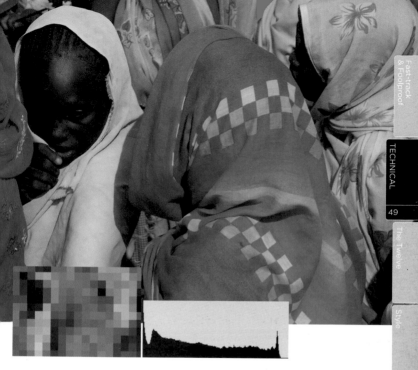

COLORFUL TONES

As explained in the text, the colorful garments were the main key tone (actually concentrating on the orange), but there was also a need to hold shadow detail in the one face turned this way. Fortunately, there was no conflict between the two key tones.

Often there is one clear contender for the key tone, influenced not only by what you intend as the main subject, but also by what is expected. However, there may be competing claims for key tone. Two areas, possibly more, may have to be catered for. The image of the Darfur women here is a case in point. According to my judgment, there were two key tones, meaning two areas where the exposure had to be right. There's the girl's face, her head half-turned, with her dark skin that had to read as dark yet with all the essential details. The second area was the rest of the image, the mass of colorful *tobes*, as these Sudanese garments are called. I wanted these strong in color, so not overexposed, while recognizing that orange is inherently a bright color. The question then is, or was, can one exposure satisfy both? The answer is yes, in this case, as the histogram shows.

In summary, it's hard to overemphasize the importance of thinking in terms of key tones. Even if you choose to call them by another term, or call them nothing at all, they are at the core of choosing the exposure.

Scene Priorities

Identifying the key tones in an image is the first step in ensuring that the exposure is right for what you want, and it goes hand in hand with deciding what is *not* important.

This becomes especially relevant when you are dealing with a high-contrast scene—that is, with a dynamic range higher than the camera and sensor can cope with. If the dynamic range is higher than the sensor can cope with, you may have to accept a compromise in the exposure, getting it perfect for one area but not quite right for another. When you have this kind of conflict, you have to allocate priorities, and often very quickly.

It's important to get into the habit of thinking about which tonal areas are important in any scene, and you don't even need a camera to do this. Step one is to decide what is the most important area—the key tone. Step two is to see if there are any other areas that ideally should be at a particular brightness. If there are, then you automatically have a first key tone followed by a second and maybe more. Another way of looking at this, which comes more naturally to some people, is to say, "That's the area I want to set at a particular brightness, *but* I also want this other area to be such-and-such."

If you do have different key tone priorities, the next question is, by setting the first key tone to a particular brightness level, what will happen to the others by default? In other words, how far away will they be from what you wanted?

A TWO-PRIORITY SCENE

In this scene of a Canadian church mainly in open shadow but with a small yet significant area brightly sunlit, there were clearly two priorities in mind—two key tones. The first was the area surrounding the focus of interest, the two men. That had to be bright enough to read clearly. At the same time, however, I did not want to overexpose the sunlit patch, and this could easily clip because of the light white paint finish. Ordinarily, without the sunlit area, I would have increased exposure for the first key tone by about a stop and a half above average. In this case, to protect the sunlit area, I increased the exposure for the key tone by 2/3 stop only.

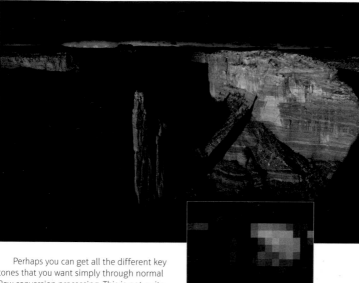

Fast-track & Foolproof

TECHNICAL

51

The Twelve

Style

Post-processing

Reference

Perhaps you can get all the different key tones that you want simply through normal Raw conversion processing. This is not quite such a clear-cut proposition, because while Raw converters usually allow very strong adjustments to Exposure, Highlight Recovery, Shadow Fill, and so on, the cost may be an unacceptable loss of image quality, such as in noise or in an overall effect that just looks abnormal. On the whole, extreme Raw converter settings are a poor substitute for managing the exposure properly in the first place. And, as the example here shows, it may be better to accept blown highlights and blocked-up shadows than trying to recover both with an unrealistic appearance.

If the answer to the above is that no exposure will be ideal, then the decisions involve either changing the way you take the picture, or accepting a compromise. A third alternative is to use one of the more advanced digital post-processing techniques, which might call for a series of exposures.

A THREE-PRIORITY SCENE

Spider Rock in Arizona, with a very fortunate break in the clouds late in the afternoon. Dramatic landscape lighting like this works because it combines shafts of light striking the scene at a shallow angle, with resulting strong and often interesting shadows, and also because it contrasts the sunlit areas with a deep, stormy sky. Put bluntly, contrast rules here. For me, the first priority was to hold the major sunlit area of cliff brighter than average but still retain all detail and good color. Typically I would expose about 2/3 stop higher than the average reading for this area. Second, though, I needed to keep the light on Spider Rock itself close to average. The difference in brightness between the two distinct areas of rock was because of the surface reflectance, not the lighting, which was equal for both. Third, I wanted the sky as dark as possible, for maximum atmospheric contrast. These were the priorities for the scene, and in this case they offered no conflict. I would have preferred the lit parts of Spider Rock to be about 1/2 a stop brighter, closer to the larger areas of cliff-face, but that was the way it was. I can easily adjust this in post-production if I wish, but to stay true to the situation I prefer to leave it as it is.

Exposure and Color

The exposure you choose has a special effect on the appearance of colors, and it's not quite as simple an effect as many people imagine. Overexposure weakens the intensity of any hue, while underexposure strengthens it—but only to a point, and depending on the particular color.

The most vision-friendly way of defining color is by the three qualities Hue, Saturation, and Brightness (HSB). This pretty well matches the way we think about color—if and when we *do* think about it. Hue is what most people mean when they say "color," the essential quality of being blue or red or green or purple, and so on. Saturation is the purity of the color, and brightness makes up the third parameter. Varying the exposure changes the brightness of a color, but this is complicated by the fact that different colors exist only in different ranges of brightness. Yellow, as the extreme example, can never be dark. If you underexpose significantly it becomes another color—ochre. Blue, in contrast, retains its essential blueness at any exposure.

Intentional slight underexposure was a common practice for photographers using color transparency film, especially among professionals shooting for reproduction in magazines and books, as their aim was to get strong colors. They relied on the ability of the repro house and/or printers to pull back the overall loss of brightness while holding the color. The same, with even more control possible, applies in digital photography. This is, of course, only if you *want* strong, rich colors. It's also important to know the limits for doing this. As a general rule, slight underexposure increases the intensity of hues, while strong underexposure just darkens them toward black. Overexposure reduces the primary characteristics of hue, creating paler and paler tones.

This kind of color control through exposure may conflict with other image needs. One of the most common conflicts is a colorful sunset. Maximum color intensity is at the expense of detail on the ground, which often leads people to shooting silhouettes for this kind of landscape photograph. Multi-shot exposure blending is one digital solution.

COLORS REACT DIFFERENTLY TO VARYING EXPOSURE

In this color pattern, the spectrum of pure hues varies with exposure, from underexposure at the left to overexposure at the right. Although it is not easy to relate this to a typical photograph, it shows how some colors, such as yellow, change their basic character (yellow becomes brown), while others, notably blue, remain consistent.

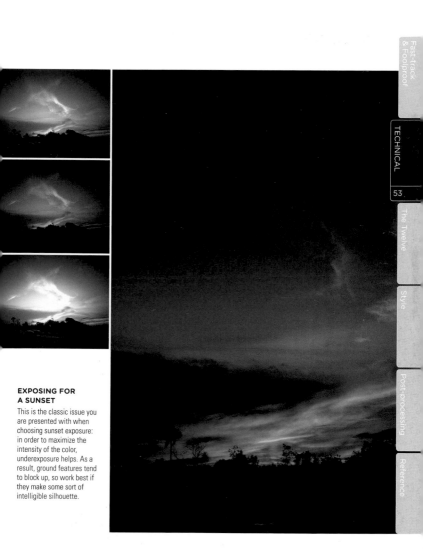

Fast-track & Foolproof

TECHNICAL

53

The Twelve

Style

Post-processing

Reference

EXPOSING FOR A SUNSET

This is the classic issue you are presented with when choosing sunset exposure: in order to maximize the intensity of the color, underexposure helps. As a result, ground features tend to block up, so work best if they make some sort of intelligible silhouette.

Exposing for Color

Let's take a step beyond the previous pages and consider what it means to adapt the exposure to the needs of particular colors, by which I mean adapting it for specific hues.

As we just saw, different colors are at their most saturated, or most pure, at different brightnesses. This means that for each color there is one ideal exposure that delivers the combination of brightness and purity. This is easiest and clearest to do with colors that are already fairly pure, but difficult to judge, for instance, with an earth color or a drab green.

There is no reason why this should complicate exposure decisions. Rather, it stresses how important it is, if you are shooting with an eye for good color, to think about how colors respond to exposure. All you have to do is simply factor this in to your basic assessment of the scene. In the Decision Flow at the start of this book, this means deciding how you want a particular color to look in the image, identifying if there's likely to be a problem with it, and making it a key tone.

The time to pay extra attention to the colors in an image is when they are contributing more than usual. Not every image relies on its color content, and not every photographer has the same interest in color. For some scenes and some people, color is simply there by default, and does not have a special role to play. At other times, and quite often for me at least, color can be partly the reason for actually shooting. This adds an extra layer of thought to the shot; so when some of the colors need to be either strong or accurate, make a point of thinking what varying the exposure might do to them.

Fast-track & Foolproof

TECHNICAL

55

The Twelve

Style

Post processing

Reference

*f*9

*f*10

*f*14

*f*16

*f*11

*f*13

*f*18

*f*22

STRONG COLORS

I've chosen this scene for its strong urban colors; to show the effects more easily. The exposure differences, created during Raw processing, which is perfectly valid for this exposure range of 2 ⅓ stops, are in ⅓-stop steps. From this sequence of exposures, we can see that some are better for certain colors than for others. The yellow, for example, looks purest at a higher exposure, while darker it becomes ochre and drab. The magenta-red reproduces well when somewhat darker. In making such judgments, you need to use your eye,

and importantly your perception of the scene as you see it directly. It's for this last reason that I can be confident that this magenta-red looks best at an exposure of *f*14. Having made this point, though, what practical use can you make of it? The answer is in two ways. One is to consider the purity of certain colors in a scene when assigning the key tone. The other is realizing that you can alter or restore the purity of a hue during processing, particularly with a Raw file.

Bracketing

A long-established technique for dealing with uncertainty in exposure is to range the exposure up and down over a series of frames, from a few to several.

In the days of film, this was costly, but now it doesn't cost anything. The choice is between bracketing the aperture or the shutter speed, and there are arguments for both. Many cameras now offer an automated burst of exposure bracketing. This speeds up the process and is also useful for any subject containing movement that you intend to treat as an exposure blend or HDR image (see Chapter 5). Bracketing the aperture takes advantage at the darker end of more depth of field from a smaller f-stop, and allows the shutter speed to stay constant in situations where that is important. Bracketing the shutter speed keeps the geometry and detail of each frame identical, which is necessary in multishot techniques (see the last paragraph). All current DSLR cameras have auto-bracketing, with a choice of the number of steps up and down, and of the size of each step.

Be warned that not everyone thinks that bracketing is a good idea, or even approves of it. The argument is that bracketing exposures is counter-skillful, rather like using a shotgun for target practice, *then* deciding which pellet won. Also, many people believe that any photographer who has mastered the craft ought to be able to achieve the perfect exposure in one. These are both true, but it *is* good insurance for those times when the importance of capturing the image outweighs personal performance.

There is a second, more digital reason for bracketing—not for choice but for coverage of the dynamic range. An increasing number of processing techniques make use of a series of frames in order to construct the final image,

SKY TO GROUND

Bracketing may be the only way to deal with shooting into the light. In this mountain scene in Wales, the steps are large—2 f-stops between exposures—and between them encompass most of the scene's dynamic range. To render a final version that contains everything, from sky to foreground, some form of blending or even HDR tone-mapping will be necessary. The scene's dynamic range is too big for carefully recovered Raw processing.

and two of the most useful are exposure blending and High Dynamic Range Imaging (HDRI). I'll deal with these in the last chapter, but they significantly alter the shooting possibilities. The circumstances need to allow the camera to be steady so that the frames are all in register, and while this ideally means a tripod and a subject that is polite enough not to move, like a landscape, other digital processing techniques can cope with a certain amount of movement, both of camera or subject. These involve alignment based on content, and work by locating the same graphic features in each image and then either re-positioning or warping to match.

BRACKET TO BLEND

This street scene in Barcelona, Spain, had a high dynamic range due to deep shadows, high sun, and very clear air. As an experiment in blending, I shot the nine-frame sequence, in 1 stop steps, handheld—hardly ideal conditions— combining some camera movement and considerable subject movement as people walked toward me. Frame alignment in the blending software (Photomatix), however, coped perfectly with the first issue, and the motion variance managed moderately well with the second. To deal with the inevitable overlaps and ghosting, I later copied the blended version onto the single exposure that was best for the moving people, and selectively erased with a brush.

THE TWELVE

I can certainly be accused of over-simplification in claiming that there are only 12 types of exposure situations, especially as Nikon, for example, uses a database of more than 30,000 images as reference in its metering systems. Yet the vast majority are simply subsets of this essential group, and it means that for the purposes of exposure any scene you shoot can be assigned to one of just 12 types. And each of these calls for a different kind of decision.

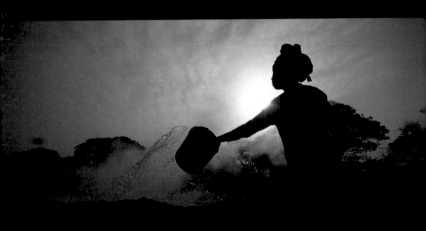

Fast-track & Foolproof

Technical

Style

Post-processing

Reference

How do I arrive at this number? Simply by long experience—my own and that of other professionals I know. Not that any of us thinks consciously of an exposure classification like this. We shoot every day, so the way we assess types of scenes subconsciously has simply been built up over time and is embedded somewhere in our brains. I generally don't have to think too hard about what kind of exposure situation is in front of me, because of long familiarity, yet part of my brain quickly assigns the scene to something I've dealt with before. All I'm doing here, in what I consider to be the key chapter of this book, is to articulate a collective experience. You can give each of the 12 situations any name that you choose, but they are each distinct and real. Whatever you see through the camera's viewfinder, or on the LCD screen, will match one of these.

CLASSIC SILHOUETTE
Silhouettes work when the outline is recognizable against the background, but the exposure has to make sure that the figure stays dark and colors behind rich.

MORNING MIST
A foggy start in England's Fen District treated by keeping the contrast low and the overall image darker than average, in keeping with the way it felt.

Embedded in this breakdown of scene types are two important assumptions, both of which might seem fairly obvious but are worth spelling out. One is the concept of key tones: which is that one or more areas in a scene have a commanding importance. The other is the recognition that most people expect most subjects to be close to average in tone, unless there is a special reason otherwise—for instance, evening scenes are darker because we experience the failing light.

First Group (The Range Fits)

This, in a way, is the ideal group. The dynamic range of the scene fits the dynamic range of the sensor—or vice versa. Obviously, there has to be some flexibility in the definition of "fits," but if we let common sense rule, it means no clipping on the one hand, and the histogram within, say, 5–10% of the limits on the other. If you shoot Raw, the extra dynamic range makes some difference, although not as much as is often claimed by its advocates.

Let's start by getting used to looking at images in different ways, making use of simple, accessible digital processing. I've already introduced the pixelated matrix, with its 18 squares on the longer side of the image, as a way of reducing an image to tonal distribution without the content interfering. To do this for yourself in Photoshop, simply make a copy of an image, reduce it in size to 1200 pixels on the longer side, then desaturate it. Finally use a Mosaic filter

QUICK LOOK

At a glance, an experienced eye should be able to tell in a scene like this that the dynamic range will fit a typical sensor response. First spot the maximum and minimum (water highlights and shadow below the parapet) and make a judgment. Ignoring the tiny specular highlights in the water, the average brightness for each is within range.

Fast-track & Foolproof

Technical

THE TWELVE

61

Style

Post-processing

Reference

(in Photoshop this resides in the Pixelate submenu), choosing 67 for the Cell Size. When there is a key tone area to identify, I use a yellow outline. When it comes to mimicking the action of a meter, the area chosen is simply averaged (*Filter> Blur>Average*). Again, this can be a useful exercise to do with your own images, or selected parts of them.

However, processing and looking at the images in these ways is only for analysis, not something to do during shooting. A partial exception is the histogram, and even then it depends on how much time you have to make the shot. If you are shooting anything the least bit active, there probably won't be any time at all. In this case, you might consider making a test shot of the scene before the action starts, or during a lull, to make sure you've judged it correctly.

CHECK THE SCENE BEFORE THE ACTION
When there is obviously not going to be time to check the histogram for whether or not the dynamic range fits during the action, as in this polo match, do it before.

1 Range Fits—Average Key Tones Average

The sensor can just cope with the range of the scene, and the scene is sufficiently normal that an average mid-tone rendering does the job. If all photography were like this, exposure would never be a problem and there would be no need for this book.

Naturally, there are still a few decisions to make, mainly about whether the scene as a whole or the most important part of it should indeed be average in tone, and some finer decisions on whether the exposure should be just a touch darker or lighter according to taste. Lighting situations like the examples here are almost impossible to get wrong.

What is critical, however, is being able to confidently to assign the right scenes to this type. The three examples here are chosen to show varieties of "average." The South American cayman (of the alligator family) is an example of a central subject that calls for a mid-tone. The landscape of rice fields is

different in that the pattern as a whole should be average (and no significant part of it is out of range). The assortment of objects is a studio shot in which there is total control over the lighting. Whenever I can I'll be including studio or controlled situations, because they usually allow more time to calculate the exposure and the way of working tends to be different.

In theory, if the two dynamic ranges—scene and sensor—match, metered average exposure should result in no clipping at either end. In practice, there are lighting situations that can still throw the meter, which of course is the purpose of the key-tone system promoted in this book. The only significant problem you might have with this is when the key tone that is meant to be average is right at one end of the range. Exposing for this key tone can tip the other end of the range over into clipping, but this is not common.

CAYMAN SEQUENCE

At a glance, this image of a South American cayman seems to be well within range, although the small highlights and small areas of shadow around the head make it fit rather more closely than you might suspect. This is a straightforward case of exposure, with the cayman, isolated in its pool of water, the obvious subject. There is a slight difference between the subject and the key tone (as there often is) in that the key is the reptile's back. The head, with its shadows, is a little darker, but practically not enough to make a difference. The average brightness for this area, outlined in yellow in the pixelated version, is 48%, which is hardly different from the overall average of 46%. This is a problem-free exposure situation.

Fast-track & Foolproof

Technical

THE TWELVE

63

Style

Post-processing

Reference

ANGKOR RICEFIELDS

Possibly more common than a defined single key tone is this kind of situation, when several tones are scattered around the frame, making it hard to say which, if any, should be the key. Nevertheless, the average of all of them, the entire frame, should be average. There is a very small subject that makes a difference to the image—the man walking between fields in the lower right of the frame—but while the timing of the shot was obviously made for him, he is so small in the frame as to be an irrelevance for working out the exposure. Notice that the average brightness for the frame is five percent less than mid-brightness. "Average" does not have to be precise; I simply preferred it slightly darker. In practice, what happens with a shot like this is that a quick glance shows it is within range and is simply a candidate for unadjusted average metering. The capture settings were 400 mm efl, ISO 50, $1/125$ sec, $f8$.

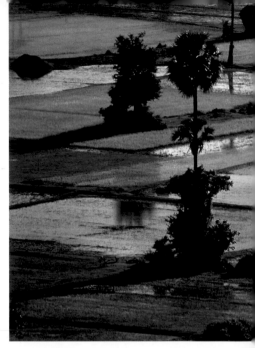

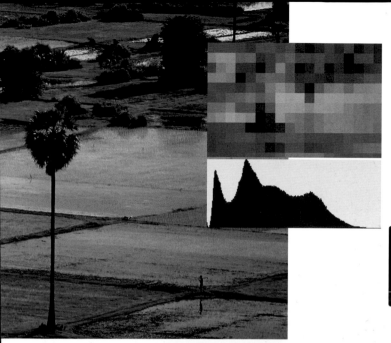

Fast-track & Foolproof

Technical

THE TWELVE

65

Style

Post-processing

Reference

OLD CHINESE OBJECTS

An artist's collection of antique Chinese objects, including a terracotta head, scissors, and an arrowhead. At a glance, the scene in the way it is framed and cropped is average in tone, a fraction darker than average. In fact, I added a low, raking spotlight from lower left, quite weak, in order to liven up what was rather flat ambient lighting. Again at a glance, the only areas to draw attention for exposure are the highlights and shadows around the head. The bright patch on the chin facing the spotlight needs to hold, while the shadows on the other side of the head are really in no danger of blocking up. In other words, an average-toned scene which has had its range lifted by a spotlight. Strengthening the spot (it had a dimmer control) might take the highlight close to clipping, but adjusting it was completely under my control.
Capture settings: 105 mm efl, ISO 160, 25 sec, f38.

2 Range Fits—Bright Key Tones Bright

In this scene, the range is still neither high nor low, but the difference is that the subject (or most of it) is light by nature, and we want to keep it that way.

Some of the naturally light subjects that immediately spring to mind are snow, white walls in an interior, and a white dress. These are, of course, the lightest things, but there are many other surfaces that are still so light yet are still light in the way we expect them to look, such as pale Caucasian skin. Whether or not the dynamic range fits is

down to the other objects in the scene, and in these two examples there is nothing seriously dark that would make the dynamic range high. If the key tones take up much of the frame, as in the examples here of the interior and the aerial snowscape, an average meter reading will *not* give the right result, and both these scenes called for adjusting the exposure to be higher than average. These are the simplest kinds of images that are bright, but the dynamic range fits.

80%

SNOW AND ROCK

An aerial view of an Icelandic snowscape. It's not all snow, as there are many dark cliffs, and in fact the upper third of the picture is such an even mix of dark rock, snow, and clouds that it would merit a normal average exposure. The key tone, however, is the large expanse of a snowfield in the lower center, which, added to the one on the far left, make up a quarter of

the area of the image. Smooth and featureless, it must not be clipped, yet it needs to be rendered as bright as possible—around 80% brightness would be safe, meaning about 2 f-stops higher than average. The ideal method here would be a center-circle reading aimed at the snowfield, then compensated two stops up.

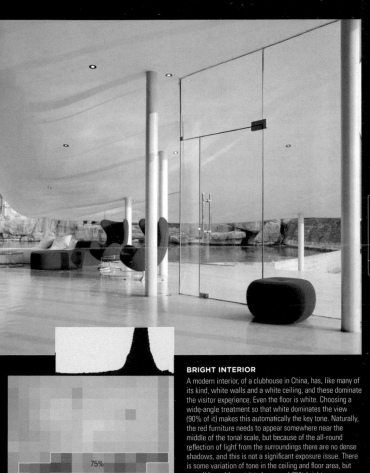

Fast-track
& Foolproof

Technical

THE TWELVE

67

Style

Post-processing

Reference

75%

BRIGHT INTERIOR

A modern interior, of a clubhouse in China, has, like many of its kind, white walls and a white ceiling, and these dominate the visitor experience. Even the floor is white. Choosing a wide-angle treatment so that white dominates the view (90% of it) makes this automatically the key tone. Naturally, the red furniture needs to appear somewhere near the middle of the tonal scale, but because of the all-round reflection of light from the surroundings there are no dense shadows, and this is not a significant exposure issue. There is some variation of tone in the ceiling and floor area, but overall I would want it to be around 75% brightness—almost two stops brighter than an average reading. The pixelated diagram and the histogram show the effect.

A variation on bright key tones is when they take up only a part of the scene. Here you need to exercise a little more judgment than in the very obvious cases shown on the previous pages. It goes back to the first step in the Decision Flow shown on pages 14–15—knowing what you want from the image. Here, in the case of the two girls on the grass, it's easy to see that their blouses are the key tones, and that they need to appear white and light but without clipping. As they are the smaller part of the image, adjusting the exposure so they look like this is not as obvious as it was on the last two pages; the exposure needs to be upped by around ½ stop. The interior with the green drapes is a slightly different case from the interior on the previous pages. The key tones are general—a mixture of the drapes, sofa, and cushions— and we want to keep them light and upbeat.

60+%

KEY TONE IDENTIFICATION

This seating area in a Beijing restaurant is in a window bay, so that the light falling on the upholstery, cushions, and green drapes is higher than on the foreground. This overall brighter area is the key tone—a sort of "composite" key tone. The white fabric needs to be held below clipping, although the brightest tones outside are not important. Treating them all as one tonal unit simplifies the metering, and I judged it to need around one stop more than average.

TWO TONES

There are really only two tonal blocks in this image; the white blouses and the grass. Everything else is just a minor variation. When a white-ish subject is prominent it usually becomes the key tone, so you need to decide just how bright it should be. This isn't snow so it doesn't need to be blindingly white, perhaps around 70%. The white blouses take up less than 10% of the area, so just a touch lighter than an average reading will do. I compensated from an overall reading by increasing just half a stop.

Fast-track & Foolproof

Technical

THE TWELVE

69

Style

Post-processing

Reference

70%

3 Range Fits—Dark Key Tones Dark

The third alternative when the dynamic range fits is when the subject is naturally dark, meaning we know or expect it to appear darker than average.

The examples I've chosen here are both works of art. One is a picture of a ceramic sculpture, the other of a painting, and in the case of the painting I had both the opportunity and need to think very carefully about exactly how dark it should be. I discussed this at length with the artist as we photographed the painting, then looked at the results on a laptop. In some ways, dark subjects are open to more interpretation than light ones. The danger of clipping is always uppermost in my mind with a light subject, and this tends to dictate the exposure, but

absolute clipping in the shadows doesn't happen quite so readily—there are often some very low pixel values that look black but are not quite, at around levels 1 to 5. This gives more flexibility, while at the same time there is also an innate tendency among many people to want to open up shadows and see more detail. However, this does not always lead to better results. It may be clearer and with more information, but perhaps with less atmosphere. Nevertheless, if there's a possibility that you may later want to open up the shadows, doing it at the processing stage, even with the Raw converter, may show up unwanted noise.

BLACK CERAMIC

The modern Chinese ceramic sculpture, of which this is a detail view, is black. Being black, we need to keep it that way, and there is some flexibility of choice that is limited only by the highlights on the collar and the left pocket, which need to be held. In fact, it is these highlights that keep the dynamic range up and improve definition. As seen, the perceived effect was more open—brighter—than the final image, which I wanted to keep distinctly rich and dark. Essentially, this meant metering just the dark area, which took up most of the frame, and compensating by reducing the exposure 2½ stops down from the average reading—hence 20% brightness for this area.

Fast-track & Foolproof

Technical

THE TWELVE

71

Style

Post-processing

Reference

DARK ARTS

Staying with modern Chinese art, here is a portrait of Shao Fan, a leading Beijing artist, painting one of his *Black* series. Here again, we have a subject that we *know* is and should remain very dark—dark enough to qualify as being "black." With the portrait, however, there's a small dilemma. Exposing to render the painting as dark as this, around 15% brightness, would mean underexposing by around 3 stops, and this would look too dark for the rest of the image. The choice I made here was to moderate the darkness of the painting in favor of the artist and white wall, on the grounds that this is a photograph rather than a copy-shot of a painting for reproduction. This meant about 40% brightness, which is one stop less than average. It is more realistic for the scene as a whole, but less realistic for the painting.

DARK AS THE SUBJECT

This picture, intended to show a light in its switched off state on a black background, needed the exposure to be set so that even the relative highlights were in the low midtone to shadow range.

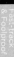

Second Group (Low Range)

Surprisingly few scenes across the range of photography come in significantly under the average for dynamic range, or "flat" as many people would call them.

This is surprising because you would expect that if the dynamic range of the sensor fitting the scene is some kind of norm, there would be a more or less equal spread of high and low dynamic range scenes around it. Ultimately, this reflects the present state of sensors more than anything else. Technically, there is still some way to go.

Yet apart from this sensor issue, just our ordinary experience of seeing suggests that this kind of scene is less than common. In interiors and in studio photography, subjects and lighting can usually be arranged to create whatever dynamic range you want, but in regular outdoor shooting the main ingredient is usually atmosphere. Haze, mist, fog, and dust all diffuse the light and act like a filter that evens out tones in the scene. This does not mean that these atmospheric conditions automatically produce a low dynamic range—far from it if you explore the possibilities of viewpoint. There is usually some directionality to the light, and if you shoot in the direction of the sun, however muffled it is by fog or mist, you will usually find a distinct gradient of brightness.

The significant feature of low dynamic range images is that they offer major choice in

LOW DYNAMIC RANGE

A typical low dynamic range scene, due entirely to early morning fog along a river. The histogram highlights its short range of tones, which sit centered with large gaps on either side. That the histogram is centered also shows that the metering method was essentially averaging, without compensation. The extra space on the left (toward dark) and on the right (toward bright) allows a range of exposure choice without incurring clipping. Opposite are the simulated results of lowering and raising the exposure as far as possible while still staying within range.

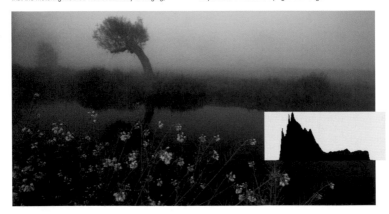

Fast-track
& Foolproof

Technical

THE TWELVE

73

Style

Post-processing

Reference

the overall brightness. Having so much choice makes it especially important to exercise caution in not overdoing the adjustments. In particular, there's often a temptation to expand the range of tones to fit the scale, to close up the black and white points as a basic

processing procedure. Indeed, choosing the auto option in Photoshop Levels does this. Superficially, it may look like an improvement, but it's easy to lose the essential softness of the lighting conditions by doing this.

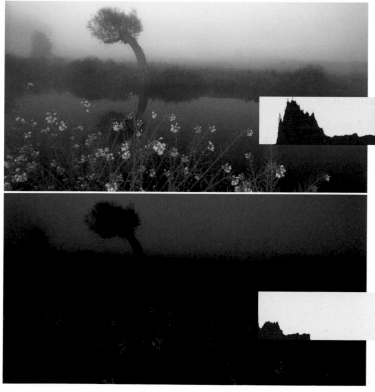

4 Low—Average Average

If the key tones are average and the dynamic range is low, it's likely that the range of tones in the histogram will be centered and with quite a bit of room to spare on either side.

This exposure situation offers more choice than any other, because there is room up and down the exposure scale without the risk of clipping. So, freedom of choice is the main characteristic, especially when shooting Raw, which allows later adjustments if you want, with negligible or no quality cost.

As mentioned on the previous pages, the choice to vary the exposure also extends to expanding the tonal range, with a corresponding increase in contrast. If you are shooting Raw, which is always recommended, the contrast settings are unimportant as you can choose these later when you process through a Raw converter. If you are shooting TIFF or JPEG, on the other hand, consider whether your default contrast settings will be useful for these uncontrasty scene conditions. The temptation to smarten things up by

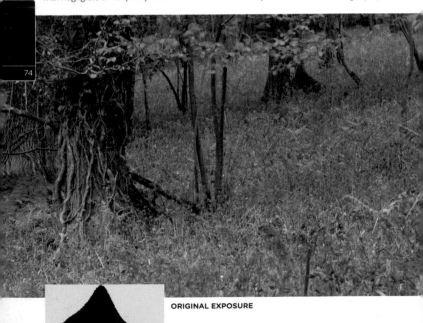

ORIGINAL EXPOSURE

setting a higher contrast may be natural, but it's essential first to consider the character of the lighting and how you want it to appear in the final image. If you want to maintain the low contrast, and perhaps even accentuate it, then avoid the usual processing method of closing up the black and white points.

An important point to note with low dynamic range lighting—or "flat" lighting as it is sometimes called—is that because there is no great difference between the various areas within the scene, average readings of the whole frame work well. Unlike higher dynamic range situations, there is no urgency to find a particular key tone and meter for that. There are rarely any mistakes with this kind of lighting situation.

Fast-track & Foolproof

Technical

THE TWELVE

75

Style

Post-processing

Reference

AVERAGE TONED IMAGE

A woodland field of bluebells, shot using average metering and with the accompanying histogram. The bell-shaped curve of tones sit in the middle with room to spare on the left and right, although there is not quite as much room on the right because of small highlights. Shooting Raw allows the exposure to be re-visited, which in the case of a low dynamic range scene is especially useful, like that shown. Also shown are the minimum and maximum exposures without clipping, and finally a version in which the raw processor settings of Exposure and Contrast have been adjusted for an "equalized" effect, essentially stretching the tones to fill the range.

FULL EXPOSURE

MINIMUM EXPOSURE

MAXIMUM EXPOSURE

ORIGINAL SCENE

This is the original scene, again low in range because of atmospheric conditions, processed with the Raw converter settings in "neutral"—that is, default. Compare the histogram with the scale on pages 16–17 and you can see that combined, there is almost 3 stops spare left and right: the dynamic range covers only around 6 stops.

MAXIMUM EXPOSURE

As this Raw processed result shows, the Exposure can be pushed a stop and a half without any clipping.

MINIMUM EXPOSURE

In the opposite direction, the Exposure can be pulled down by almost a stop. The mood changes created by these exposure adjustments are significant.

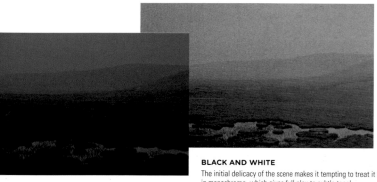

Fast-track
& Foolproof

Technical

THE TWELVE

77

Style

Post-processing

Reference

BLACK AND WHITE

The initial delicacy of the scene makes it tempting to treat it in monochrome, which gives full play to subtle tonal adjustments. I decided here to pursue delicacy. In the first step, the image is converted to grayscale using the auto setting, which lowers the values of the warm end of the spectrum plus aquas. Next, the Exposure is lowered strongly, the black point moved in substantially, and Clarity moved to a high setting (90 in ACR). Finally, a reverse, contrast-lowering tone curve is applied.

EQUALIZED IMAGE

Equalizing the image involves stretching the tones to fit the range, which in a raw converter involves the combination of increased Exposure, pushing in the Blacks (black point) and increasing Contrast and Clarity for good measure. The equivalent of this in Levels, with an already processed TIFF or JPEG, is to push in the black point and white point sliders until they touch the ends of the tonal range. The effect is stronger, with more punch, although I think it loses the essential soft quality of the original scene.

SPLIT TONE

Taking this somber theme further, we can also add split toning to give a suggestion of color and an almost historical effect. As usual with split toning, contrasting the hue between highlights and shadows emphasizes the effect. Here, the sky highlights (and their reflections in the water) are pushed toward the cool colors, while the shadows are pushed toward warmer colors.

5 Low—Bright Bright

This exposure situation has a lot in common with that on pages 66–69 (the range fits type #2), but the difference is that here there are no important shadow areas.

The subjects are naturally light, as we expect them to be, and the exposure needs to be pitched high, by possibly one or two stops according to the scene. Doing this will give you true high-key photography, and for more on this style see page 132. Naturally light subjects include snow, white walls, white fabrics, and puffy summer clouds. Enveloping lighting conditions with plenty of reflectors often feature in this kind of exposure situation as the diffuse illumination keeps shadows light and soft, and sometimes removes them altogether, such as with mist and fog outdoors, or light tents and large cyclorama lighting in a studio. The usual precaution, as with any scene that has light tones, is to avoid

highlight clipping. Judging the exposure needs care to get the result bright but also making sure you stop short of losing all detail. As with Low—Average situations, overall metering of the entire frame is fine; the only difference is that you need to increase the exposure from the reading. As you can see from the examples here, "bright" generally means somewhere between 1½ and 3 stops brighter than average or, in percentages, around 65–85% brightness overall.

SHAKER HOUSE IN FOG

A foggy view *without* foreground. *With* would have encouraged an exposure closer to average overall. As it is, the appeal of the scene, looking down a slope toward a Shaker village in Maine, is an evenness of tone with the sense of buildings just emerging from the fog. As fog in principle is perceived to be light, like cloud, this suggested a light treatment of almost 2 stops more than average, around 70% brightness, as the histogram shows.

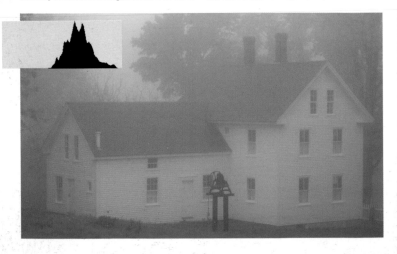

Fast-track & Foolproof

Technical

THE TWELVE

79

Style

Post-processing

Reference

WHITE SHELVES

The dynamic range in this lit shot of shelves in a modern design shop appears to be greater than it really is, due partly to the red splash of color that gives a different sensation of contrast, and partly to our expectations of hard-edged shadows. In fact, as the histogram shows, the range covers about two-thirds of the scale including the red, and half if we discount the red. As the surfaces are all obviously intended to be white from our experience, the exposure needs to be very full. In fact, it is overall the same as for the foggy Shaker view, but the range within it goes from 50% mid-tone for the bottom left shadow to 90% brightness for the fully-lit surfaces.

HISTOGRAM INCLUDING RED

HISTOGRAM EXCLUDING RED

6 Low—Dark Dark

This exposure situation is by no means as common as the other two in the Low group, and the reason for this is the simple average of most people's taste. There seems to be a natural human tendency to want images brighter rather than darker, all other things being equal.

Because the dynamic range is low, the problems of avoiding clipping are much less urgent, so this choice of darker or brighter exists. This is one kind of low-key situation,

but as we'll see later, most low-key images tend to have some small bright tones, which raises the dynamic range.

This is prime territory for moody, somber, subdued imagery, and I'll explore this more in Chapter 4 Style, under *Low key*, *In praise of shadows*, *Deep shadow choices*, and *Another kind of low key*. Ultimately, it comes down to having a reason for the general mood of the image to be darker than usual, as you can see with these two examples.

DARKER SKIN TONES

This is a portrait taken in Swat, northern Pakistan, that I deliberately made darker than average, for a simple matter of taste rather than for any technical reason. The brighter version is perfectly average for the man, excluding the almost uniformly dark background. Metering here is reasonably straightforward so long as the face is the area of attention.

The normal option would be the brighter one. Yet the skin and the incredible lines and dark intensity of the area around the eyes all seemed to me to want a richer, deeper treatment. In addition, I did not want the beard to contrast too strongly with the darker face. For these reasons, compensating by one stop to make it darker was what I chose.

SIMULATED AVERAGE READING

ORIGINAL

Fast-track
& Foolproof

Technical

THE TWELVE

81

Style

Post-processing

Reference

SMOGGY SCENE

With the exception of the tiny specular highlights at the top toward the right, the dynamic range of this telephoto city scene from London is low. The reasons for it being low are the industrial pollution from this rather depressed area along some rail sidings, the exaggeration of this atmosphere by the 400 mm lens looking across a few hundred meters, and the overall drabness of unpainted brickwork, pavement, and cast-iron structures. Much of it is also in shadow from the extremely weak early morning sunlight. The feeling of industrial urban drabness and a general air of inattention lends itself naturally to a darker- than-average treatment, and this is what I chose. The overall brightness as I shot it is 33%, about 1⅓ stops underexposed from average, and that is the compensation I gave. I took only one shot, but we can simulate (below) what it would have looked like given a normal, average reading by adjusting in Photoshop. I think it would look a lot less effective.

Third Group (High Range)

This is where exposure decisions become very interesting, when the range of the scene is too much for the sensor. Something has to give, and in every one of these situations the photographer needs to think about potentially lost highlights or shadows.

The solutions, however, are many and various, and by no means is the high range necessarily a problem. In the next chapter we'll look in more detail at creative and stylistic ways of handling a high range, but here too, over the following pages, I present a variety of solutions. High range is also referred to traditionally as over-scaled and sometimes as high-contrast, though that strictly should refer to the gamma rather than the lost ends of the scale (pages 34–35 *Contrast, High and Low*). I try to avoid using the expression "high dynamic range" because that now has a very specific meaning, which includes special HDR techniques and should, in my view, be limited to images with at least 14–15 stops of range (see pages 32–33 *Scene Dynamic Range* and pages 168–173 *HDR Imaging*).

All the examples shown in this section are necessarily compressed into the range of the printed paper, which makes it a little dangerous to compare them directly with, for example, the low range images we've just been looking at. This might seem obvious, but I think it's worth the reminder. The images here, such as the two on this page, have all been rendered in a way that makes them acceptable, but in fact the only way you can get a true sense of a high-range image is by shooting in Raw and examining it in a Raw converter such as Photoshop's ACR.

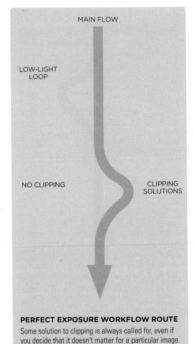

PERFECT EXPOSURE WORKFLOW ROUTE
Some solution to clipping is always called for, even if you decide that it doesn't matter for a particular image. In the Decision Flow process, consider the clipping solution loop.

UNEVEN LIGHT

Bright sunlight through a window falling across a sofa and an old Chinese opium pillow creates standard conditions for a medium-high dynamic range—a range that will probably exceed the dynamic range of the camera's sensor. The distance from the window, which is a few meters, gives the shaft of light the quality of a spotlight, and ensures that the shadows remain dense, with little spill to lighten them.

Fast-track & Foolproof

Technical

THE TWELVE

83

Style

Post-processing

Reference

DAYLIGHT THROUGH WINDOWS

One predictable high-range situation is an unlit interior with views out onto a sunlit exterior. Within the interior part of the image the dynamic range is already high, as it is a combination of the fairly bright sunlight streaming in, a number of deeply recessed shadows, and surfaces that vary from white paint to black cast iron. Yet even this range of about 8 stops is only a part of the full range that includes the scene outside, which extends it to 12 stops or more.

This is the most common lighting situation when the range is high, which means, given that camera sensors in general have a lower dynamic range than ideal, this is overall one of the most common situations faced by many photographers.

It's worth stressing again, however, that it depends very much on your style of photography. As a simple example, if you favor shooting into the light for its atmospheric effect, you will inevitably face more high-range situations and clipped images than other photographers might.

By definition, high range means that some clipping is inevitable, so typically the scene has an extreme mixture of tones, as the pixelated version shows. This splattering of tones from potentially blown highlights to blocked-up shadows is what tends to distract people from thinking clearly about the exposure. What do you base the exposure on when there is so much to choose from? For one answer to this let's go back briefly to the idea of the default, the "normal," exposure, as on pages 42–43 *Objectively Correct*. For reasons to do with perception, the eye feels

MORNING LIGHT

A sunrise view of the central towers of Angkor Wat, Cambodia. The clear winter air makes it certain that from deep shadow into the light, the range will be very high. The schematic shows how the scene blocks out into five main areas of tone and color. The brightest areas of the sky and the deepest shadows were certain to be out of range in a single exposure, but I didn't mind this. In fact, I positioned

the camera to make the strong shadow area on the right, a stone portico, work simply as a silhouette. The two key tones were the sunlit areas of stone, and second, the mid-shadow areas. The sunlit part was measured and the exposure set for exactly that. This means the mid-shadows are dark, but still full of recognizable detail (in the Zone System this would be called textured shadow), at about 2½ stops less.

Fast-track & Foolproof

Technical

THE TWELVE

85

Style

Post-processing

Reference

comfortable when the main focus of interest in an image—in other words, the subject—appears at medium brightness. Medium brightness means a mid-tone, or average, around 50%, and this, as we've seen in Chapter 2, is the premise for all meter measurements. This is what viewers tend to expect, and qualifies it for the default. However, as we'll see throughout this book, and especially in Chapter 4, Style, default is only ever a starting point. Ultimately, the choice is a creative one and becomes that of the photographer.

BRIGHT LIGHT AND MIDTONES

This is a different kind of situation, though still high-range, in which there are certainly mid-tones, but they are scattered. The mixture of tones is less cohesive than in the Angkor Wat picture, with the result that, in a fast-moving situation such as this of a scene at Port Sudan docks, there is no obvious large area to measure. At the same time, as the schematic diagram shows, the different tonal groups are fairly evenly represented, which is something that was obvious at first glance. Given this, and also being cautious about clipping, which would be expected in the brightest highlights and the deepest shadows, I could be fairly sure that an average meter reading would work. Indeed, this was what I did, on the reasonable assumption that there would be enough leeway with a Raw file to recover any small amount of clipping easily. The clipping is, as shown here, quite small, and simply choosing the auto option in Photoshop ACR recovered it all. A little extra work, mainly raising Exposure, Blacks, and Clarity, gave more shadow recovery and better mid-scale contrast.

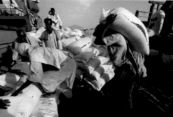

ASSESSING CLIPPING

A street scene in Lijiang, Yunnan, China, which is high range because of the altitude and clarity of the air (strong sun, deep shadows) and because of the range of reflective surfaces, from a bright white wall to dark stone. It was clear that there would be strong clipping at whatever exposure, but the important question was, would it matter? The important areas for content and tone are as shown in the schematic diagram. The deepest shadows on the right were in fact irrelevant to the image, and most of the white wall is featureless so that

could be allowed to clip with no harm done. As for the metering method, I used the smart, predictive mode, and this automatically protected the whites from clipping excessively—the result is as shown with the clipping warnings. This, incidentally, is a reduction of almost one stop from an overall average, and that's the camera's exposure algorithms at work. During Raw processing, choosing auto in Photoshop's ACR completed the highlight recovery.

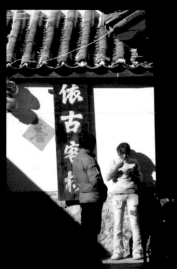

BEFORE

KEY IMAGE AREAS

Fast-track & Foolproof

Technical

THE TWELVE

87

Style

Post-processing

Reference

CLIPPED AREAS

FINAL RESULT AFTER ACR

8 High—Large Brighter Against Dark

In this high-range situation, the subject is much brighter than the surroundings and usually there are reasons for wanting it to be brighter than an average rendering.

As we've seen already in the other two groups, Range Fits and Low, some subjects are inherently light. This means that we feel they should be lighter than an average mid-tone from our familiarity and experience. The usual examples are pale skin, the kind of clouds that do not threaten rain, anything obviously painted white (and our perception is instinctively good at realizing that a white

picket fence should be white rather than gray), and large sources of light. Light sources can be light emitters, like a lamp or the sun, in which case they are normally small in the frame if you include them, but they can also include, for instance, a window seen from inside. Naked lamps and any source that appears small in the frame can usually be treated as a specular and allowed to burn out (see pages 150–151). Broad sources, on the other hand, like a lightly draped window seen from inside, call for some care.

SUBJECT ON DARK STUDIO BACKGROUND

This example, of a Fabergé cigarette case in the Louvre in Paris, is drawn from controlled studio shooting, where everything can be adjusted and there is plenty of time to make decisions. The background, which is a rich purple velvet crumpled slightly to reveal its texture, was chosen specifically for contrast—contrast of tone and of color. This contrast would give the jeweled gold case maximum visual punch. The case needed to sparkle, show off its different metallic lusters, and be bright, by about 2 stops above average, I judged. This is the result. The metering method was a handheld meter with incident-light attachment, as I would always use whenever I have the time and opportunity. Equally well, however, would have been a center-circle or spot-meter reading taken through the camera, making a 2-stop upward compensation.

Fast-track & Foolproof

Technical

THE TWELVE

89

Style

Post-processing

Reference

DARK BACKGROUND OUTSIDE

An almost identical lighting situation as that of the cigarette case—a significant coherent area that needs to be bright against a dark background, but in totally different circumstances. Here, there is no time to play around with measurements and make test exposures, just an urgent need to shoot quickly because in Buddhist prayer people do not usually hold this position for long. The lighting, from a late afternoon sun, was fairly frontal, and the surface is skin, which is itself an entire topic for consideration. How light should skin be? This depends on ethnicity, but also on the lighting conditions and on personal taste. We'll look at this again under *Memory Tones* on pages 112–113. Here, the man is Burmese, so the skin tone could well have been treated as darker. However, I wanted a strong contrast with the background, so I opted for fairly light, meaning a little less than 1 stop lighter than average. The metering method was center-circle with the appropriate compensation.

65%

9 High—Small Brighter Against Dark

This is a more difficult kind of situation to measure, simply because of the discrepancy between the bright subject area and the overwhelming dark background. The metering method of choice outside the studio is spot-metering, although the size of the spot-metering circle is usually so small that it pays to take several measurements to be sure.

Center-circle measurements suffer because the diameter of the measuring circle is larger than a key tone of the size shown here. The metering method of choice in a studio or other controlled shoot is incident-light handheld.

Note that the histogram is of little practical use with this kind of lighting situation because the small delimited area of brightness is displayed as relatively few pixels.

BLACK BACKGROUND

A studio shot, this time of bizarrely shaped diamonds. The background is black velvet, chosen so that it would drop right out. No texture at all was wanted from that. These are raw diamonds, so they are uncut, but nevertheless some of them show natural facets, and the colorless ones have expectedly bright highlights on the facets that reflect the overhead softbox area light. One precaution was to avoid these clipping, but given the time available this was hardly an issue—there was ample time to make tests. More important was judging the precise key tone among the varied diamonds. They all needed to be rendered lighter than average (diamonds are not perceived as or expected to be dark, or even mid-toned), but even so there is variety of tone, as the pixelated version shows. In my judgment, the brown diamond on the lower left made a good subject for the key tone, and I wanted it to be around 60% brightness, which is about ⅔ stop above average. I used a handheld meter with incident-light attachment for the reading, and compensated upward by ⅔ stop.

Fast-track & Foolproof

Technical

THE TWELVE

91

Style

Post-processing

Reference

7%

20%

50%

LIMITED LIT AREA

A view from within the maze-like temple of Bayon at Angkor, Cambodia, looking up through a stone window toward one of the many face-towers. The lit area plus sky takes up less than 5% of the picture area, which is much less than the approximate 12% of a 12 mm center-circle. An overall average reading is useless—as you can see here, the average brightness of the whole frame is only 7%. The average reading from within a 12 mm circle is also dark, 20% brightness, meaning that a center-circle reading is likely to overexpose the shot by between one and two stops. A spot reading on the sunlit stone gets the exposure where it should be.

10 High—Edge-lit Edge-lit Subject

Of all the 12 lighting situations, this is the most specific, probably the rarest, and undoubtedly the most tricky. As we'll see in the next chapter, *Style*, edge lighting is one of the core conditions of low-key imaging and it certainly merits its own entry in our list of lighting situations.

One thing that makes this situation special is that the brightness of the edge that works best varies according to the situation, and also according to what you want from the image. For example, if the edge is very thin, it may be acceptable to expose so that it is completely blown out as a highlight. If it is broader, then it is likely to be showing more detail and possibly color, in which case there is more of a case for exposing so that it is simply bright, not clipped. But then also consider a situation in which the shadowed area of the subject has a good amount of fill, from light reflected by the surroundings. The picture of the two women walking is an example of this. In this case, you might well choose an exposure that takes this filled shadow as the key tone, rendering it somewhat darker than average, and let the edge blow out. Clearly these are fast decisions to make and they are heavily influenced by taste.

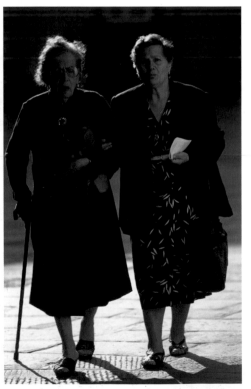

EDGE BUT NOT KEY
The edge-lighting on the hair and shoulders of two women walking across an Italian piazza helps significantly to make the picture, but the key tone arguably is their faces and dresses, in shadow but illuminated by reflected sunlight from the pavement. This needs to be readable, even if more than 2 stops darker than average.

Fast-track & Foolproof

Technical

THE TWELVE

93

Style

Post-processing

Reference

30%

OVERALL AVERAGE

26%

AVERAGE SHADOW AREA

HIGHLIGHTS

PERSONAL JUDGMENT ONLY

There are no typical edge-lit shots: each one is different, not only in the way that the light falls and is reflected, but also in the interpretation that each photographer makes. This scene, of a Shan woman smoking a cheroot in a morning market, is just one example. It is by no means typical or translatable to other images, but it will serve to show the issues involved in judging exposure. Edge-lit subjects always have a significant dark area, though this is rather less than usual here because sunlight catches the out-of-focus objects behind. The exposure compensation will have to be darker than a normal meter reading, but the trick is deciding by how much. The woman takes up about half of the area of the frame, and the edge-lit areas as I define them about 10%—that is, about 20% of her. The lighting is made less clear by the bright reflections behind, although as it turns out not by as much as you might think. The average brightness for the entire frame is quite low, as you might expect—30%, around a stop and a half darker than average—but the overall brightness for just the woman is not that much different, at 26%. Basically, this means that an average in-camera meter reading would overexpose according to my taste by a stop and a half, and indeed what I did at the time was to use center-weighted metering and compensate with about a stop and a half less exposure. Could the shot have been exposed differently yet still be good? Yes, of course. It could have gone darker for more of a silhouette, and it could also have been opened up by a little less than a stop to reveal more shadow detail at the expense of small clipped highlights.

Having worked through the theory of judging the right brightness for these edge-lit subjects, the practical matter of metering is still a major problem, particularly if you have to shoot quickly, as in street photography. The most reliable method takes time and works only for static subjects—incident light metering with a handheld meter—and you could argue that if you have enough time to measure the exposure in this way, you have enough time to bracket the exposures and choose the best one.

There is no easy and foolproof answer, because the intensity and area of edge lighting varies so much. The examples here go into some detail to show this. Any direct meter reading, which is what all SLRs use (even though a few modify this with an incident measurement via a small diffused sensor on the camera body) is influenced by the area measured. Obviously, the more concentrated this is on the actual edge-lit surface, the more accurate it can be, but this is often impractical. In other words, of the three usual metering modes, which are evaluative or matrix (entire area divided into regions and processed predictively by the camera), center-weighted, and spot, the last is the natural accurate choice. However, in a moving situation such as photographing people, there just isn't time. Center-weighting is particularly dangerous to rely on, not only because the central area shades off, but also because many cameras do not show its extent. Worse still, as most of the image area in an edge-lit shot is dark, even if the spot or center-weighting options do display the circular metered areas, they are very difficult to see against black.

OVERALL BRIGHTNESS 12%

12 MM CENTER CIRCLE 18%

OFF-CENTER CIRCLE 20%

HIGHLIGHT BRIGHTNESS 50%

MEASURING THE EDGE

Let's take a detailed look at a shot that relies almost completely on edge lighting. Given the nature of this situation, which is a man in a Burmese café photographed surreptitiously from quite close (the next table), there was time for only one shot so it isn't possible to show what it would have looked like with different settings. It is, however, exposed exactly as I hoped (and there's enough uncertainty in these situations for hope to play a part). No metering system currently available can cope satisfactorily with a lighting situation like this. Smart, predictive systems are not yet smart enough to know that this might be the effect you want, although frankly it should be possible.

If we do some post-analysis on the image, we can see how far off an average reading would be—the overall brightness is only 12%, meaning around 3 stops darker than average, so that in-camera an average reading would overexpose by that amount. The difference is too great to allow accurate compensation. If we measure just the equivalent of a 12 mm center-circle, the overall brightness comes out as 18%, which is one stop more. This means that a center-circle reading when shooting would overexpose by about 2 stops, which is better. In this case the edge light is conveniently in the middle, but this is by no means always the case so let's do something that can always be

reproduced—aim the center-circle at the brightest part of the edge lighting. Doing this in Photoshop, as here, gives an overall brightness for that area of 20%, which is more or less the same.

This is my own preferred method in uncontrolled situations—center-circle, aim at the brightest, compensate with 2 stops less. The problem, of course, is that edge lighting can vary wildly in how it looks. In this case, the area that I've outlined contains all the important tones, and takes up only 3% of the area of the frame, even though it looks more. Within this small area there are still differences, and in this case I would want, if I had time to think about it, an average exposure, meaning 50% brightness. A 12 mm center-circle actually occupies 12% of the area of a full-frame SLR image, so we're taking a reading of an area that is around four or five times less. If you think about it like this, in terms of area, then an adjustment of 2 stops (which is four times more) makes sense.

With edge lighting and a direct reading through the camera's system, you will always need to compensate by reducing exposure, and it helps to have some kind of method. The only accurate measurement methods for edge lighting are spot-metering and incident-light handheld readings, and neither is possible in a situation like this

Fast-track & Foolproof

Technical

THE TWELVE

95

Style

Post-processing

Reference

In the absence of anything better, my method is to use the matrix or smart predictive metering mode and reduce the exposure from that according to informed guesswork. You might think it's not much of a method, but it gets me to within a stop. Practice and experience are the keys here. And there *is* a way that you can practice at home. It's disarmingly simple. Just put up a previously photographed edge-lit shot on

your monitor, making sure that the screen background is black, turn the room lights off and aim the camera at the screen, just filling the viewfinder with the image. This is better done on a tripod. The actual light measurement is unimportant; what you are experimenting with is the *exposure compensation*. With my camera, a Nikon D3, the compensation needed with smart mode is in the region of 2½ stops (minus, that is).

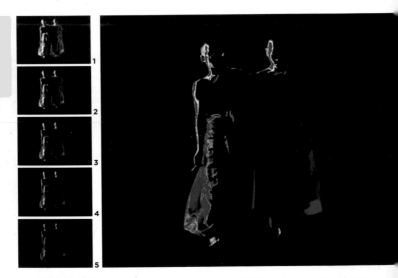

PRACTICE AT HOME

Take any edge-lit photograph that you have already shot, display it on a monitor screen, darken the room, and re-photograph it at different exposures using your preferred metering mode (such as center-weighted or smart). Open the results in Photoshop (here in the Raw converter) and keep the clipping highlight warning on. The setting at which the highlights are not clipped will give you an indication of the compensation you need, as described in the text. Here, minus 2½ stops is about right for me. Depending on the metering mode, there may be differences according to how centered or off-centered the edge light is in the frame.

Fast-track & Foolproof

Technical

THE TWELVE

97

Style

Post-processing

Reference

INCIDENT-LIGHT READINGS WHEN POSSIBLE

This studio-lit shot of a small sculpture, aiming for a black-on-black low-key effect, allowed enough time to use the most sensible metering methods for edge lighting—a handheld meter fitted with an incident-light dome. The dome stands in for a three-dimensional object, and as you can see when you take the reading, by aiming the dome at the camera from the subject's position, it collects the edge light from behind and whatever degree of shadow fill there is in front—which is not much in this case. There are two lights here, one behind and above right, the other behind and to the left. As they are each lighting different parts of the sculpture, and just the edges at that, when they are combined the reading is essentially the same, at just over ƒ11. Unlike the much more uncertain direct meter readings through an SLR, no compensation is needed. The exposure is just as the incident-light reading indicates.

11 High—Large Darker Against Bright

In this lighting situation, the subject of interest and key tone is darker than its background, and this means inevitably that either the background is going to suffer from overexposure, or you deal with the contrast by adding light, using software recovery, multiple shooting, altering the composition, or choosing to forego detail in the subject in favor of the background.

In a sense, this is the inverse of lighting situation #8, but there's an important perceptual difference. Blocked-up shadows, as we've seen earlier, are generally more acceptable to look at than burned-out highlights. (The emphasis here is on "generally," because highlight areas can be made to work in high-key images and exploiting flare for effect, as we'll explore in *High Key, Light and Bright, Flare,* and *Highlight Glow,* pages 132–139.) Just because the main area is darker than its bright setting or background does not mean that it has to reproduce in the photograph as dark. It may do, but not necessarily.

This is the second most common lighting situation in the high-range group, simply because it includes a very common kind of scene—outdoor shots with a band of sky at the top. The *arrangement* is different from an object sitting entirely within the frame, but the principle is the same.

98

DARKER TOWERS BEFORE LIGHT SKY

The central towers of Angkor Wat, as on page 84, but from a different angle and in very different weather. This is early morning in the rainy season, shooting into the light, and shot before the days of HDR and exposure blending, so there is only a single frame. While I might possibly have tried exposure blending from two or three different exposures if I had been taking the picture now, I'm still happy with the way this shot worked. In particular, I wanted a brooding, looming sense, appropriate to the moss—and lichen—covered stones, which called for an intentionally dark treatment. I had decided on an exposure around 2 stops less

than average for the stone—a drastic reduction, but necessary for the effect to have the atmosphere I was looking for. The reading was taken with a handheld meter and reflected-light attachment, the equivalent of using a camera's center-circle measurement. A secondary advantage of this low exposure was that some of the sky would read well. Vignetting from the wide-angle lens (efl 21 mm) accounts for some of the darkening toward the corners, but this helped the effect of light streaming out from behind the towers. The average brightness from the entire frame was a mid-tone, but I did not use that for a reading.

Fast-track & Foolproof

Technical

THE TWELVE

99

Style

Post-processing

Reference

SILHOUETTE

This is an example of the silhouette option. Silhouettes, which by definition are devoid of almost all detail, work because of their outlines, and so long as this makes visual sense to a viewer, they solve the high-range exposure problem by letting you expose for the bright background. I chose this case because there was a little uncertainty about how well the image (a Burmese construction worker pouring water on lime) would work as a silhouette. The upper half of the woman is clear, the lower half less so, and the exposure needed to show some separation between the legs and the background. The tree behind confuses it slightly. Even so, I chose this route for what I thought would be a graphically more interesting image, and relied on the timing of her outstretched arm, the bucket, and the flow of water. Given the movement and need to shoot quickly, there was a considerable amount of guesswork in the exposure. I used the camera's smart metering and compensated by opening up one f-stop for this shot, but I also shot many frames and bracketed the compensation to be on the safe side. The average overall brightness for this shot was 28%.

HIGH HORIZON

A typical example of a high horizon line with a sky that will inevitably clip if the main subject—and key tone—is the foreground. Shooting into the light in this kind of situation, with a low morning sun, gives attractive reflections and a pleasantly atmospheric flare (see *Flare* pages 136–137), all of which I wanted. The backlighting meant that most of the foreground subjects, like the two women, were showing their shadowed sides toward the camera. This, plus the

highlight reflections on the scales and fish, made a darker-than-average treatment appropriate. In fact, I underexposed by ½ stop from the center-weighted meter reading (which as usual is already compensating for a bright strip of sky at the top, see *Metering Modes* pages 36–39), and the result is as I wanted it. Note also that I kept the framing so that only a narrow strip of sky shows.

STUDIO-LIT BOOK

An arranged and lit photograph of one of the copies of the famous Domesday Book. This is a very typical product-shot arrangement, out of any context and as simple as possible. The background, while not irrelevant, is definitely subsidiary to the group of books. This being a studio shot, the lighting is under control, and so the dynamic range can and should be brought within the range of the camera sensor. Nevertheless, I wanted two things that would make the range high. One was to have strong contrast within the composition of the books to avoid the rather bland subject matter appearing even blander. The other was to knock out

the lower part of the background. I used a light table, comprising an upward curving sheet of translucent Plexiglas lit from beneath, and the idea was for this base lighting to give some "lift" to the books and the gentle gradation behind to help the sense of presence. In other words, I wanted the base to go to pure white. For the grouping of books, I wanted an average exposure, 50% brightness, and used an incident light attachment on my flashmeter. An average reading of the entire frame was 65%, but as this depends on the amount of background visible, it would never be a sensible reading to follow.

Fast-track & Foolproof

Technical

THE TWELVE

101

Style

Post-processing

Reference

12 High—Small Darker Against Bright

The final lighting situation in the list is a small subject and key tone that is darker than its surroundings.

The major difference between this and the previous one, in which the dark subject occupies a reasonable amount of the frame, is that here the background always dominates exposure decisions, and is often the part of the image area that you need to measure.

This very much depends on how important it is to open up shadow detail within the small subject. The smaller it is in the frame, the less this matters.

DUAL SUBJECTS
There are two subjects in this photograph taken at the entrance to an old communal circular clan building in China's Fujian province—the woman walking with panniers and the animals carved in relief on the flagstones. In fact, I had started with the animals, but when the woman approached I decided quickly to use her as a kind of indicator to the unusual carvings, pointing the way, so to speak. The eye is first drawn to the woman, because she's moving, and because of the contrast in tone. In terms of exposure, the woman as the subject is small enough in the frame, and has such a clear outline that she works as a near-silhouette. In other words, the real key tone is the ground. A slightly brighter-than-average treatment seems to works best here, and in fact I used the camera's smart metering mode and compensated upward ⅓ stop.



Fast-track & Foolproof

Technical

THE TWELVE

103

Style

Post-processing

Reference

MOMA SPACE

This image, shot in New York's Museum of Modern Art, relies on its geometric composition, and on the spatial relationship between the men sitting on the bench and the artworks on the wall. Strictly speaking, the key tone would be their skin tones, but this area was too small in the frame to measure, and in any case, a simpler, faster, and more practical method was to increase the exposure by almost two f-stops from the overall reading. A glance shows that the walls and ceiling are white, and a workable rule of thumb when this tone dominates the frame is to compensate the exposure upward by 1½ stops.

SUBTLE SHADOWS ON WHITE

A studio shot of an artist's pigment, with a large amount of white space left surrounding it for layout reasons. A certain amount of invisible effort went into getting the shadow on the right-hand side of the phial just right, using reflectors, and on evening out the light fall-off from left to right while still keeping the sense of a single broad light on the left. In a case like this, documenting the exact hue and tone of the

pigment is paramount. This was part of a series of similar shots, and a natural precaution was to use a ColorChecker target at the beginning so that accuracy could be guaranteed when processing the Raw files. The only sensible metering method in a situation like this is a handheld meter with incident light attachment. A reflected light reading would have been pointless with so much white paper background

Fast track & Foolproof

Technical

THE TWELVE

105

Style

Post-processing

Reference

BIRD IN FLIGHT

One of the most uncertain exposure situations, even though very straightforward, is anything in the sky, such as a plane or a bird. For various reasons, from erratic movement to the limits of focal length, it is often necessary to play it safe and leave plenty of room around the subject, and this can play havoc with exposure measurement. The background dominates, and you have no control over it. It is hard to believe, but these two shots of a peregrine falcon were taken two frames apart, against different parts of the sky. The shot against the white cloud typifies the problem. The bird is small in the frame because I was using a prime lens 80 mml and it was further away than I would have liked.

Practically, this was not such a problem because the magazine (this was an assignment) would simply crop in. However, metering was difficult because the sky tone was changing by the second as I panned to follow the bird. In a fast-moving situation like this, the only thing to do is to anticipate the different background tones likely, and be quick-fingered at changing the exposure. My rule of thumb here was plus 1 stop for a blue sky, plus 2 stops for white. I find it quicker to set exposure to manual and operate a single dial rather than use yet another finger to hold down a compensation button. This choice depends on how your camera handles exposure compensation.

STYLE

The theme of the last two chapters has been finding
the exposure that best suits the situation. This has
meant taking into account some important technical
issues, such as the dynamic range of the sensor and
of the scene, taking accurate measurements, and
identifying what is the important area or subject.

Now I want to move things on to the next level, which is to take all of this and temper it with judgment and creativity. As I already touched on in *Objectively Correct* on pages 42–43, the notion of just one exposure being "right" is quite risky. While there's no doubt that there is a fairly narrow band of exposure for any one image that the majority of people would prefer, good photography involves self-expression, and this opens up the choice even for something that might seem so mundane as exposure.

In exposure, there is no wrong and there is no right. If you embrace this, and I believe you should, you take your chances and fall back on your judgment. Like any artist, you have to stand by your own opinion. Not everyone will agree with what you do, but does that matter? There's a certain safeness in trying to get the image to a state that most of your audience will like. It's safe, yes, but courageous, no. If you treat photography as a kind of business, with results based on market acceptance, as many people do, then you should stick with the received wisdom and the objective "rightness" that the last chapter dealt with. However, rest assured that the imagery will fall short of being interesting, personal and, dare I say it, completely worthwhile. This applies across the range of creative expression in photography, and exposure is very much a part of this. Most photographers tend to play safe, and it's entirely forgivable, but nevertheless…

It's fashionable but trite to claim that there is no such thing as correct exposure. However, for each individual photographer in every picture situation there is indeed one perfect exposure that satisfies both technical and creative needs. It matters less that the result may differ according to personal taste than knowing how to achieve what you want from a photograph.

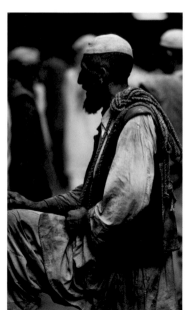

EMERGING DAWN

Keeping the exposure less than average gives a valuable vignetting effect and enriches the colors of first light over a Venezuelan river.

MATCHING THE SUBJECT

Muted colors from a lower exposure and low contrast gave a better feel for a market scene in Pakistan's Northwest Frontier Province.

Mood, Not Information

The idea of optimal exposure, which, as we've seen, is largely built around assigning mid-tones to most subjects, follows the premise of delivering good information. A clear view with all the essential detail visible is about as close as we can get to the concept of an objectively "correct" exposure, and most situations warrant this kind of treatment.

However, it by no means applies to all situations. Photography in all its aspects starts to become interesting when you make your own interpretation of a scene, not just following the obvious. This applies to composition—what you define as the subject, viewpoint, and much else, including exposure.

It may seem on the face of it that in choosing an individual expression of brightness all you are doing is making the image darker or brighter, but this apparently simple action influences much more in the way the photograph will be read.

Here, for example, are three images that have been given extreme exposure, all for good reasons, even though not everyone would agree with the results. The silhouetted shot of the rock arch, in particular, has become quite a different kind of image from what it ordinarily would have been, and the content is hardly recognizable.

108

(see pages 52–55 *Exposure and Color* and *Exposing for Color*)

SKYE

Black-and-white imagery lends itself particularly well to strong variations in exposure for mood, because there are no associated shifts in hue (see pages 52–55 *Exposure and Color* and *Exposing for Color* for more on this). Shooting into the light, this river on the Isle of Skye in the Scottish Hebrides, lent itself to a dark, brooding treatment by underexposing, and by recovering sky detail and shadows by dodging and burning. In fact, the visual impression of the scene was much less dramatic, brighter, and flatter than the image here. Exposure is one of the most powerful techniques for creative photographic interpretation.

Fast-track & Foolproof

Technical

The Twelve

STYLE

Post-processing

Reference

EXTREME EXPOSURE

The opposite direction is to overexpose to extreme, as here with a backlit arrangement of orchids. With this kind of lighting setup, a studio flash aimed directly toward the camera from behind a sheet of milky translucent Plexiglas, the usual precautions are to mask right down to just outside the image area, using black card, to minimize lens flare. The version on the left is the conventional bright-but-not-quite- clipped treatment, basically 2 stops brighter than a direct through-the-lens reading. The second version is overexposed by one more stop. The result is certainly not conventional, and many people would consider it a mistake, but what it does is to stress color and light at the expense of shape. Note that increasing the exposure opens up the detail and hue of the interior of the blooms.

LANDSCAPE ARCH

One of many natural sandstone arches in Utah. Their outlines against the sky make these arches prime material for graphic compositions, but they are also over-photographed. On this occasion, in the late afternoon, the sky was a flawless blue—and boring. Changing the camera position with a view to hiding the sun's disc behind the thin span of rock, I was looking for a silhouette. Then I found a more interesting, slightly surreal effect with a dark exposure that made it only just possible to distinguish black from dark, rich blue. The key to this was holding down the camera's depth-of-field preview button with the small aperture chosen (f22). This is something I frequently do with potential silhouettes (see pages 148–149).

Personalized Exposure

Extending the idea of the last two pages, the argument is that exposure can be taken further than the technical skill needed to suit the scene and the subject.

It can be made into a creative tool to help explore personal ideas about imagery. Some photographers even develop what others would call under- or overexposure into a signature. The reasons for wanting to go dark or go bright are always personal, and not even necessary to explain, but they require that, as a photographer, you know what you want from the image.

PAKISTANI CLOUDS

Overlooking the hills of Pakistan's North-West Frontier, bordering Afghanistan, I waited for dawn to shoot an overview of the tribal area. I did this several times, and on most days the view was clear but uninteresting during the long, dry August days. On this day, however, we had storm clouds gathering in the east, and I finally had the makings of a landscape. I needed a scenic view like this in order to set the scene for a book. It wasn't a matter of responding to an interesting view, more of making something interesting out of a landscape lacking in conventional physical drama. My solution was to use the sky and make more of it in the composition. The multi-layered clouds and the arrangement of the light created a landscape in the sky, and I made sure that I exposed for this, leaving the land below, with its low hills and farms, still in pre-dawn light.

Fast-track & Foolproof

Technical

The Twelve

STYLE

111

Post processing

Reference

AN EXERCISE IN ATMOSPHERE

This assembled shot in an old garden shed, to illustrate a feature on herbs, needed to balance information (the assemblage of fresh and dried plants and leaves) with atmosphere (the evocation of old country life, hidden corners, and the sense of time stood still). The solution was to light the shed in a completely natural way, with minimum shadow fill and including the window in frame (for atmosphere) while positioning the herbs in light that would reveal them clearly. In other words, composition here is the main technique for dealing with the lighting. To heighten the desired atmosphere further, I wanted no hint of detail from the garden outside, which is the opposite of what is normally sought from an interior looking out.

To do this, I hung a large sheet of tracing paper outside the window, and aimed a 1600 joules naked flash from directly outside, boosting the weak, cloudy daylight and making it more directional. A single white card reflector on the right gave a hint of detail to the deep shadows. The metering was done with a handheld incident light meter, this being a set-up allowing plenty of time, and the exposure was ƒ16 at ISO 200, which is ⅓-stop less than the incident light reading.

Memory Tones

Most people are familiar with the idea of memory colors—those colors that are so familiar we expect them to reproduce in a certain way and are especially sensitive to them in our perception. Less commonly referred to are memory tones, but the principle is the same.

Indeed, most of the subjects and surfaces are the same, with skin leading the list, but in this instance it is the lightness or darkness that is important. In practice, it is not easy to separate our judgment of tone from that of color and, as we'll see, altering the exposure to change the lightness definitely affects our sense of the precise color. In black-and-white, of course, there is only tone to consider, and if your camera allows you to shoot monochrome, judging memory tones is simpler. However, this is complicated by having to decide precisely how bright different colors should appear in black-and-white.

Skin is arguably the most "memorized" of memory tones, given the overwhelming visual importance of people and in particular faces. And it varies hugely according to ethnicity and taste. Just as some people sunbathe to darken their skin tone by choice, others use hats, sunblock, and even parasols to keep it pale, and ideals of how dark or light skin should appear differ between individuals and societies. That is why this exposure decision properly belongs here in the *Style* chapter rather than earlier under *Technical*.

Green vegetation, from grass to leaves, also raises expectations about how light or dark it should appear. Unlike skin, which most people tend to prefer to be less saturated rather than more saturated in color, the general preference is for a strong sense of "greenness," and usually this encourages images a little lighter than average. There is a more technical reason as well, which is that

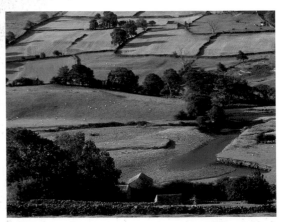

GREENS
The full range of greens is more varied than most people imagine, and even in a single view, like this of a valley in Yorkshire, it reveals a range of hues and tones. Indeed, hue and tone are closely related because, as most people's preference is for over-saturation of "grassy" green (a fact known by film manufacturers, some of whom, notably Fuji, adjusted the dyes in certain emulsions to suit popular taste), this effect comes across better when lighter. In other words, popular taste wants grass to be bright and strongly hued.

the sensitivity of the HVS (Human Visual System) peaks in the yellow-green part of the spectrum. It is still a good idea to avoid paleness, especially for grass, but most people would rather not see green leaves distinctly dark. Again, though, this is a matter of personal taste.

Skies are the third major subject in photographs that tend to be judged against how we remember them. Like green plants, blue skies are often remembered as being more colorful than they actually were. Not only did film manufacturers acquire a lot of experience in formulating emulsions to match customers' ideals, but camera manufacturers also now regularly adjust settings to give people what they want, rather than realism and accuracy. Richness in a blue sky generally calls for a *lower* exposure.

SKY BLUE?

How blue should the sky be? Again, this is influenced strongly by popular taste, which tends toward better saturation of the blue. As this pair of images shows, perhaps counter-intuitively, a more saturated blue sky is also lighter, by a small amount.

FLESH TONES

Perceptually, we are highly sensitized to flesh tones, or rather, to the flesh tones with which we are familiar. There is a surprisingly narrow range of acceptability, as illustrated here with a picture of a girl with pale Caucasian skin. The middle exposure looks "right," but even the modest change of 2/3 stop up or down, as in the other versions, looks "wrong." If we take just the skin area, we can see that from shadow to light there is a range of about 2 stops, with an average overall brightness of 67% for the "correct" exposure. This exposure range is perfectly acceptable because the eye sees it as related to the way in which the light falls on the face and the shadows that are cast. In other words, we perceive the skin as being of the same lightness, simply varying because of the illumination. The average brightness for this kind of Caucasian skin needs to be between about 60% and 70%, around 1 stop brighter than an average reading. Other kinds of skin need very different exposure compensations.

MID

LIGHTER **DARKER**

Fast-track & Foolproof

Technical

The Twelve

STYLE

113

Post-processing

Reference

Envision

I use the term envision to refresh a clear idea that has become clouded by, of all things, the Zone System of Ansel Adams et al. I'll get on to that topic in a few pages, but one of the crucial steps in exposure is being able to imagine how the image will look if you give it a certain exposure—in other words, being able to envision it.

For many photographers, this concept was hijacked by the clumsy term previsualization, invented unnecessarily by Ansel Adams to describe the first step in his Zone System. However, whereas the Zone System always has been a method best suited to landscape and architectural photography, or at least those scenes where the photographer has lots of time to stand around thinking, the idea of envisioning how the shot will look at any given exposure is universal. It is also logical, and something that really does come

naturally to many photographers who spend their time regularly shooting, day after day. If you don't care for either word, just think of it as forming a mental picture.

It takes a certain leap of imagination to jump from simply absorbing the scene to translating it into a photograph with a fixed and limited dynamic range. Without laboring the point, the Human Visual System (HVS) operates by rapidly and constantly scanning the scene, focusing on small areas and very quickly building up a mental picture. An essential mechanism is a kind of normalization as the eye scans. As the gaze flicks from a shadow area to a highlight, we perceive the detail within each, with very little delay. The result is that we perceive the full dynamic range of the scene in microseconds.

A single photographic image clearly doesn't work in this way, and a key skill is to

SIMULATED HUMAN OBSERVATION

envision how it might look before shooting. There are also likely to be choices, as the examples here show. Moreover, if the light is changing over the period you are shooting, this adds more variables. A landscape that is shot as the sun rises or sets, or under fast-moving clouds, is a typical case. This involves another HVS feature, called brightness constancy. This is our ability to perceive surfaces having the same brightness even though the light may change. In practice, this means, for example, that we tend not to notice the full pace of failing light at dusk, and is something to be overcome if you want to envision how a late afternoon scene will look in an hour or two's time.

ISO 200 ¹/₄ SEC *f*22

ISO 200 ¹/₆₀ SEC *f*22

Forming a mental picture

There is more than one action involved in this process of forming a mental picture. In fact, there are up to four quite distinct steps, as follows:
1. Learn to discount your eye's great efficiency at seeing detail in deep shadows and bright highlights, as your camera cannot do both.
2. Be able to imagine how a scene will reproduce if given a "normal" "average" exposure.
3. Decide how you would *like* it to look.
4. Anticipate how it might look under different lighting conditions that are practically possible, such as change in the angle of sunlight, or under controlled conditions by changing the lighting.
On the following pages we'll look at how to put this into practice.

DISCOUNTING THE WAY WE SEE

Most failures in exposure, even the small ones when the image didn't quite appear as imagined, are failures to translate from how we perceive to a strictly sensor-recorded image. Reproducing exactly how the Human Visual System perceives a scene is impossible on a printed page, but with practice all photographers learn to recognize what the eye can do that the camera cannot. In an exposure situation like this, with two quite sharply distinct areas of brightness—the ground and sky—it's important to know that a single shot will not deliver what you see. In this view of a Welsh mountain landscape looking toward a cloud-strewn sunset, what I could see approximated to the image, but it was built up from the eye's brightness adjustment for the sky and another for the rocks, and a third that spanned the transition on the horizon from ground to sky. I shot a range of exposures in order to eventually be able to reproduce this. The two exposures shown here are spaced 2 stops apart, which is a substantial range.

Fast-track & Foolproof

Technical

The Twelve

STYLE

115

Post-processing

Reference

EXPOSURE

RAW SOFTWARE AUTO

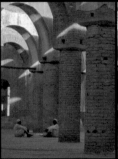

**OPEN SHADOWS
IN SOFTWARE**

SOFTWARE RECOVERY

HOW YOU WANT IT TO BE

There are often a number of ways of treating a shot simply through exposure. This view of a mosque in Sudan is a case in point. The contrast is high, and that was a prime consideration, to avoid clipping, but I had another motive as well for this exposure. I had envisioned this as a large print, and wanted the viewer's attention to come slowly to the two men sitting on the ground in the middle distance, so as to give a slight surprise at the size of the structure. The other versions of this detail show more expected treatments, that open up the shadows and rely on the Raw processor to recover some highlight detail. However, I wanted the attention to begin higher in the frame, where all the contrast is, and only later drift down to the men. The solution was exposing so that the open shadows were around 25% brightness.

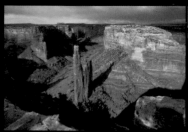

ISO 64 $^1/_{30}$ SEC *f*8

ISO 64 $^1/_{30}$ SEC *f*9

ISO 64 $^1/_{30}$ SEC *f*11

ISO 64 $^1/_{30}$ SEC *f*11

ANTICIPATING LIGHT

This kind of anticipation has a broader use than just for the exposure, as it affects the composition, the atmosphere, and the overall success or failure of the shot. However, imagining how the exposure might be as the light changes is an essential component. There was, as usual, no guarantee that the light would turn out to be in any way special as I waited for sunset. Sunlight was sporadic, and the gathering clouds threatened to extinguish it soon after the first of these images, which is fairly ordinary. Nevertheless, I needed to prepare for this possibility, however remote, because any late flash of sunlight might well be short-lived and I wanted to be able to shoot quickly, with confidence in my exposure settings. If this were going to work out at all, I wanted to know how the light and shadow would fall.

One of the things I was banking on, and suggested by this first shot, was that the movement of the sun would make it cast a large shadow behind Spider Rock. I chose my viewpoint to anticipate this, as I wanted the thin pillar

isolated by the lighting. The sunlight then disappeared for half an hour and the shoot looked pointless, but suddenly a gap began to open in the clouds (top right). At this point, the sun in its descent had not quite cleared the lower edge of the clouds, leaving the upper part of Spider Rock weakly lit. I wasn't happy with this, but shot it nevertheless. The sunlight continued across the scene for the next quarter hour, with the contrast getting stronger until this final moment (bottom left). As I had already thought about what I wanted, I knew exactly what the exposure settings should be, even though the sunlight intensity was increasing. I kept metering the brightest part of the cliff face and applying the same compensation (plus 1⅓ stop, as I had already decided). By the final shot, the light has begun to go, though the gap in the clouds persisted. Note the change in camera position in an attempt to do something with the changed distribution of light, as I stepped back to let the foreground rocks take up some of the attention lost to shadow in the lower right corner.

Fast-track & Foolproof

Technical

The Twelve

STYLE

117

Post-processing

Reference

The Zone System

The Zone System was an attempt to coordinate exposure and printing for black-and-white photography.

Yet how relevant is it for digital shooting, and indeed for shooting in color? The answer is not much, at least not in the way it was originally intended to be used. There are many people who believe in the Zone System, and there is even one excellent software processing application based on zones (LightZone), which is actually why I include it here. Ultimately, the Zone System was a solution for inadequacies in the basic photographic process—inadequacies that I believe are being tackled digitally in quite different ways. This is not what you will usually read by Zone System enthusiasts, but that's because of the mistaken belief that you can go on adapting old techniques to new circumstances.

The key concept, which remains valuable even with digital processing, is the division of the tonal range of a scene into 10 zones (although there are variations of 9 and 11). Photographing by the Zone System involved three actions. The first was to form a mental picture of how you wanted the final print to look in terms of brightness and contrast. The second was *placement*, meaning that you decided which tone in the scene you would place in which zone—in other words, assigning it a brightness level. By *placing* one tone in one zone, the other tones in the scene would

naturally *fall* in other zones. The third action was to adjust how tones would fall by varying the combination of exposure and development—essentially, contrast control. Reducing development time for a black-and-white negative, or weakening the solution, made the image lighter and less contrasty, while increasing it made the image darker and more contrasty. So, for example, if the scene were contrasty (we would now say it had a high dynamic range), you could increase the exposure and reduce the development.

Fast-track & Foolproof

Technical

The Twelve

STYLE

119

Post-processing

Reference

Clearly, this procedure has very little relevance to modern digital shooting, especially because of the need to hold highlights. Over-exposing for a high-range scene could be disastrous, because nothing would be able to restore the clipped highlights. What *is* of value, however, is the way of looking at a scene that the Zone System encouraged. The 10 zones are sensible and practical, and not at all a bad way of evaluating scenes and images.

ASSIGNING ZONES

This is an example of dividing an image into meaningful zones. Only reasonably sized areas are worth designating, as very small areas are unlikely to influence your exposure choices. However, this is not an exact procedure. In this architectural shot of a portico in quite bright sunlight, there are six obviously separated tonal blocks or zones. Assigning these to specific zones requires some judgment, and if you follow the Zone System it also means that all the zones will have a one-stop relationship to each other. In this case, using Zone System methodology I would place the shadowed area inside the dome in Zone III (textured shadows), see how the other values fall, and aim for a result in which the bright stone surrounding the entrance is in Zone VII (textured brights). In practice, the processing choices in digital photography, particularly with Raw files, have overtaken the more limited ambitions of the Zone System. Note there is a significant difference between judging zones in black and white and in color. Colors can be distracting for this exercise.

0	**Zone 0** Solid, maximum black. 0,0,0 in RGB. No detail.
I	**Zone I** Almost black, as in deep shadows. There is no discernible texture.
II	**Zone II** First hint of texture in a shadow. Mysterious and only just visible.
III	**Zone III** TEXTURED SHADOW. A key zone in many scenes and images. Texture and detail are clearly seen, such as the folds and weave of a dark fabric.
IV	**Zone IV** Typical shadow value, as in dark foliage, buildings, and landscapes.
V	**Zone V** MID-TONE. The pivotal value. Average, mid-gray, an 18% gray card. Dark skin and light foliage.
VI	**Zone VI** Average Caucasian skin, concrete in overcast light, shadows on snow in sunlit scenes.
VII	**Zone VII** TEXTURED BRIGHTS. Pale skin, light-toned and brightly lit concrete. Yellows, pinks, and other obviously light colors.
VIII	**Zone VIII** The last hint of texture. Bright white.
IX	**Zone IX** Solid white, 255, 255, 255 in RGB. Acceptable for specular highlights only.

ORIGINAL COLOR

ORIGINAL IN MONO

IDENTIFYING ZONES IN DETAIL

Traditional Zone System practice is first to make your own zone scale and then hold it in front of the scene to be photographed. I've simulated this here with a view of Mount Vernon, Virginia. Note the difference between viewing in color and in monochrome; we'll return to this later.

Sliding the scale around the view, which is more obvious here with an image than with the real scene, the tones can be matched. Because the zone scale is printed, it accurately represents the range of what is possible to print—although, of course, it works better in black-and-white.

- Zone VII matches the gable, and also the areas of the white façade on which the shadows of the trees fall.

- Zone VIII matches the bright sunlit areas of the façade.

- In this rendering of the scene there is not much Zone V material (the gravel driveway) and it is a less important zone for exposure decisions affecting this image.

- Zone IV matches the roof tiles, but with a strong warning because their red color can be translated digitally into a variety of tones.

- Zone III matches the shadowed areas behind this arch.

ZONE III

ZONE IV

ZONE V

ZONE VIII

ZONE VII

Fast-track & Foolproof

Technical

The Twelve

STYLE

121

Post-processing

Reference

What Zones Mean

What survives from the Zone System that is of lasting value is the description of the zones, and what they mean perceptually—and conceptually.

Three zones in particular have special significance because they mark key points on the scale. These are Zones III, V, and VII. Zone V is the mid-tone, so it is important for obvious reasons. Metering and exposing for it gives a 50% brightness in the image. This is also where the Human Visual System perceives the maximum information. Zone III is the darkest tone that still retains full shadow detail, while Zone VII is the lightest tone to hold full detail. Below Zone III and above Zone VII, texture and detail begin to be swallowed up by darkness and brightness respectively—detail is hinted at rather than delivering full visual information.

A broader way of looking at the scale is to say that from Zone III to Zone VII is textured,

ZONE 0
BLACK POINT

As with Zone IX at the other end of the scale, some people avoid even the smallest part reaching Zone 0, but more often it is used to ensure good contrast and a "punch" to the lower end. In short, Zone 0 equals the black point! In this image, just the darkest part of the shadow is clipped.

ZONE I
ALMOST SOLID

For some photographers, this zone is the black point, meaning even more "punch" to the overall appearance of the image. To highlight the point, this image is the same as the one above, but with the black point moved in a little (using the Levels tool). The effect is subtle, particularly on a book's printed page.

while at either end is predominantly *tonal*. All the essential information detail will be in the central 5 zones on a 10-zone scale. This does not, however, make the tonal zones (0 to II and VIII to IX) unimportant for exposure decisions. As we saw earlier, most images benefit in appearance when they just touch pure black and pure white at either end. This is why in digital processing one of the most basic steps is to set the black and white points. In Zone

System terminology, this means that Zones 0 and IX (on the 10-zone scale) are just reached but not included. The zones just outside the "textured" limits, which is to say Zones II and VIII, can also be significant in images where you want to hint at detail in an area rather than have it fully revealed.

Let's look at parts of different images for which of the zones is particularly important.

Fast-track & Foolproof

Technical

The Twelve

STYLE

123

Post-processing

Reference

ZONE II
HINT OF DETAIL

In this view looking down on buildings in the heart of the old city of Bruges in Belgium on a bright, clear day, the overall aim was to have rich, saturated colors for the sunlit rooftops, which called for less than typical exposure. This in turn made the dark shadowed areas in the narrow street important—to hold just a hint of detail.

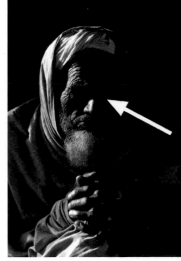

ZONE III
SHADOW DETAIL

This is the standard zone in which to place areas that show full detail, but are still distinctly in shadow, being two stops darker than an average mid-tone. This is a typical case—the shadowed area of a portrait taken in sunlight of a person with slightly dark skin.

ZONE IV
OPEN SHADOW

Often an alternative to Zone III, but the difference is that the shadows here feel very open. It is still a darker than average mid-tone, but by only one stop.

ZONE V
MID-TONE

This is the default for all meters, and in a sense the default for the human eye and brain. What this means is that if the surface you are thinking about has no prior reason to be lighter (such as a white cloud) or darker (such as a black cat), then Zone V is the default.

Fast-track & Foolproof

Technical

The Twelve

STYLE

125

Post-processing

Reference

ZONE VI
BRIGHT

Lighter than average without getting close to the sense of being a highlight. Caucasian skin, as here, is usually well suited to Zone VI—in other words, a stop brighter than the meter.

ZONE VII
HIGHLIGHT DETAIL

The highlight equivalent of textured shadow, Zone III, and with the same general qualities of having full textural detail while being part of the highlights.

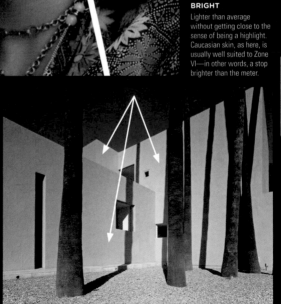

ZONE VIII
BRIGHTEST
ACCEPTABLE
HIGHLIGHT

Here, the details are on the verge of disappearing into whiteness, but not quite. There is no clipping, but this is as bright as you would want a digital image to reach, short of small specular highlights.

Fast-track
& Foolproof

Technical

The Twelve

STYLE

127

Post-processing

Reference

ZONE IX
WHITE POINT

There are two schools of thought for this top end of the scale, as there are for Zone 0. One holds that no part of the image should reach this clipping point, while the other allows it for that extra touch of clean contrast—but only if, as here, it is confined to small specular highlights and light sources.

	Updating the zone descriptions
IX	This is my summary of the 10 zones that are relevant to digital photography:
VIII	
VII	
VI	IX White point
V	VIII Brightest acceptable highlight
IV	VII Highlight detail
III	VI Bright
II	V Mid-tone
I	IV Open shadow
0	III Shadow detail
	II Hint of detail
	I Almost solid
	0 Black point

Zone Thinking

While the Zone System, as invented, is fairly pointless for digital photography, and completely pointless when shooting Raw files, the principle of analyzing scenes and images in zones is a good one.

Ansel Adams's 10-zone division is perceptually spot-on, as each of the zones refers to a brightness level that triggers a particular response in the HVS. Let's take an image and see how dividing it into zones might help exposure decisions.

The photograph is a fairly straightforward scenic view, of Cape Town in South Africa. The light was changing frequently, which meant quick decisions were needed, and I was aiming for the obvious—a rich contrast between sunlit buildings on the waterfront and storm clouds over Table Mountain in shadow. According to my usual way of dealing with exposure, the key tones would be the façades of the buildings, and I knew that I would want them to be, en masse, about one stop lighter than average. I was not analyzing the scene via the Zone System—I never do—but we can still take this approach in retrospect.

Broken down into zones, the main blocks of interest fall as follows: the brighter buildings Zone VII; the mountainside Zone III; the darker clouds Zone IV; the gray cloud top left Zone V; the clear sky below it Zone VII; and the waterfront shops in shadow Zone II. The

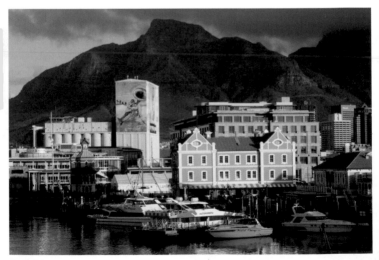

ORIGINAL
Exposed as for a center-weighted average reading.

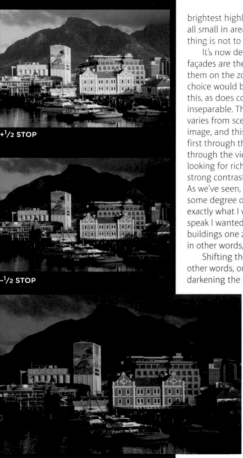

+1/2 STOP

−1/2 STOP

−1 STOP
My final choice

brightest highlights and darkest shadows are all small in area and, of these, the important thing is not to let the highlights clip.

It's now decision time: The bright building façades are the key, so where should we put them on the zone scale? The predictable choice would be Zone VII. But taste comes into this, as does color. In this case, the two were inseparable. The weight of importance of color varies from scene to scene and from image to image, and this area of judgment is filtered first through the photographer and then through the viewer. With this scene, I was looking for richness of color as much as for strong contrast between sunlight and shadow. As we've seen, rich saturated color comes from some degree of underexposure. This was exactly what I wanted, so in Zone System-speak I wanted to place the brightest sunlit buildings one zone lower than the obvious—in other words, in Zone VI.

Shifting the exposure down one zone—in other words, one stop—has the advantage of darkening the mountainside behind and also enriching the blue sky. The downside of this is that it deepens the shadowed area of waterfront shops, and while I could live with this I would ideally like it to be opened up sufficiently to show what is going on there. However, this being a digital image, I can have my cake and eat it when I process the image.

Fast-track & Foolproof

Technical

The Twelve

STYLE

129

Post-processing

Reference

Exposing for Black-and-White

You might reasonably have expected *Exposing for black-and-white* to come straight after *Exposing for color* in Chapter 2, but it really has to be treated under Style because black-and-white photography is almost entirely about *interpretation*.

After all, we don't see in monochrome, except in very low lighting, so decisions about how a scene ought to look in black-and-white are always personal ones.

There are two ways of shooting black-and-white digitally, and they call for different approaches to exposure decisions. One is to shoot in black-and-white mode, which some cameras offer. The clear advantage here, at least for exposure, is that you immediately see what you get—and depending on the camera, this does not necessarily mean that you lose the color information in the image file. The other approach is to shoot in color as normal, and then use one of the several image-editing programs available to convert into black-and-white. The technique of channel mixing has opened up a completely new world of choice and craft for black-and-white photography, making it possible to translate any color into any tone. This is actually a processing matter, but it is obviously connected with the exposure and resulting brightness.

Because black-and-white images are exclusively tonal, you could argue that they have a more direct relationship with exposure as they are uncluttered by color that actually interferes with our perception of brightness. Standard procedures do not apply quite so stringently, so that, for instance, clipping at either end of the scale can be better accepted. I'm talking about general reactions, of course. And because the modulation of tones is so evidently a part of the craft and art of black-and-white photography, there is also more

general acceptance of extremes of key—low key and high key, which we'll come to a little later in this chapter. Naturally, everyone makes their own decisions about what they like, but when it comes to general audience reactions there is more scope and more freedom in choosing exposure in black-and-white than in color.

CAMERA MONO MODE

Some cameras have a monochrome display mode, and the value of this is that it removes the distraction of any strong colors, which can overwhelm envisioning a scene in black-and-white. The image file will still be in RGB, and so can be converted with all the usual channel mixing controls.

Fast-track & Foolproof

Technical

The Twelve

STYLE

131

Post-processing

Reference

ORIGINAL COLOR

STANDARD CONVERSION

BLACK AND WHITE	
REDS	161%
YELLOWS	60%
GREENS	40%
CYANS	60%
BLUES	-111%
MAGENTAS	80%

CONVERSION TO FAVOR BRICK

BLACK AND WHITE	
REDS	85%
YELLOWS	60%
GREENS	40%
CYANS	60%
BLUES	149%
MAGENTAS	80%

CONVERSION TO FAVOR SKY

CONVERTING FROM RAW

Here is a detail of the Mount Vernon image that we looked at under Zone System, with a textured zone scale overlaid.

In the first monochrome conversion, Photoshop's Raw converter default is used. Note the relationship between the red brick tone and the blue sky tone.

In the second conversion, the red channel is raised and the blue channel lowered to favor the brick with a lighter rendering. See how the brick and sky tones correspond—they are now at Zone VII.

In the third conversion, the channel settings are reversed to favor a lighter sky. The brick tone is now at Zone III, with no area of sky that corresponds.

High Key

High key means an image composed in the upper bracket, featuring whites and near-whites. It involves what ordinarily would be considered overexposure.

These are easier to construct in the studio or other controlled situations than to find by chance in real life, as they call for more than just a full exposure. The requirements are large pale areas lacking detail (such as a white background), only very small areas that are mid-tone or darker, and especially important is a near-absence of shadows. This last point makes the light sources critical, and the most effective for high key is enveloping, diffuse light. After this, it is up to the exposure to complete the job, and there is always a choice, from normal and averaged, all the way to verging on the featureless.

As almost all hues weaken with increasing brightness, and certainly the primaries red, green, and blue, color plays very little part in most high-key images. Even so, there is scope for having an overall pastel tint, and also for judiciously introducing a single spot color that gains even more attention from being alone. On the whole, though, as with low key—the reverse of this style of exposure and composition—this is very much in the tradition of black-and-white photography. Generally, the less color there is, the more the eye pays attention to the subtleties of tone, and high key is very much about subtlety.

High-key images carry the expected associations of openness, flooding light, and if there are any emotional tendencies (by no means a given thing) they are generally upbeat and positive. As with low key, when this kind of exposure and composition succeeds, it does so by being unexpected in its avoidance of typical contrast strategies, and by showing off a certain technical mastery in achieving just the right separation of tones in a delicate, restricted range. "White-on-white" is a classic use of high key.

There's potential confusion with the cinematographic use of the term high key, as it means lighting in which key and fill lights are balanced more or less equally. The effect is bright, full, with no large shadow areas, and without mood of mystery. It's efficient rather than intriguing, but the exposure is average, not over-exposed.

HIGH KEY PORTRAIT

This portrait has been so highly exposed that almost all details other than the eyes and lips have been lost. The extreme high-key treatment works with a subject like this in which the key elements remain fully recognizable. Average brightness is almost 90%—a 3-stop exposure compensation upwards from average.

Fast-track & Foolproof

Technical

The Twelve

STYLE

133

Post processing

Reference

PEARLS SEQUENCE

Freshly extracted pearls wrapped in plastic at a pearl farm in southern Thailand. The subject and setting are both in varying shades of white, and not only call for a lighter than average exposure but also for a high-key treatment. Four alternatives are shown here—two of them compensated to give a high-key effect, while two are automated and are not at all satisfactory. The medium-bright version, which I

preferred, was exposed 2 stops brighter than the overall average reading. Even so, an exposure 1 stop brighter than this is still acceptable if you look at it in the high-key idiom, which allows for significant areas losing all detail. Compare these with an averagely exposed version, and also with this version equalized in Photoshop (using the Auto button in the Levels window), which closes up the black-and-white points.

AUTO

AVERAGE

LIGHT

LIGHTER

Light and Bright

As we have just seen, true high key demands special conditions. Even without these, however, there is a range of tastes and styles in how bright overall an image should be.

What we looked at in Chapter 2 are the technical ideals *as most people see them*. Nevertheless, this is open to considerable interpretation, and the scale of brightness preferences is wide—and often surprisingly so for photographers who deal only with their own images to their own liking. A magazine picture editor, however, or even more so a repro house, gets to see a wider range.

For fairly obvious reasons, the lower the dynamic range of the scene, the more flexibility there is in overall brightness. Here, by the way, I'm using the term brightness rather loosely, as a general appearance to do with exposure, and not in the specific sense we defined back on pages 22–23. When the dynamic range is high, the problems of clipping place more constraints. Low-range images—the second group in The Twelve—tend to be technically acceptable to anyone whether lighter or darker. However, irrespective of technical issues and the notion of keeping things within the bounds of correctness, bright is very much a point of view, or should I say a state of mind. It carries various associations, and although not perhaps universal, they include being open, obvious, fully revealed, positive, and even cheerful. So long as the degree of brightness stops short of appearing washed-out, most colors will appear purer and more saturated than in a darker version (a reminder that I'm using the word saturation in its true sense, rather than the co-opted digital imaging sense). So, in addition, bright imagery tends to be colorful.

It's also worth remembering that while we're dealing with differences in exposure—more or less light on the sensor—digital processing offers many possibilities. The ways in which a change in the exposure gets translated into a final image are surprisingly varied, and it's no longer practical to consider exposure without taking into account the processing stage.

SHADOWS
A distinctly brighter than average exposure has the effect of focusing attention on the shape of the shadows cast by two tall chimneys on the roofline of this New England building.

DARKER

LIGHTER

BRIGHT PORTRAIT

So long as the range of the scene is not especially high, as in this portrait, there is some latitude for exercising taste. The darker version is exposed at about 2/3 stop lighter than average, which is typical for a scene like this with pale skin tones (60% overall brightness). Yet the lighter version is also completely acceptable, exposed 2/3 stop lighter again (70% overall brightness). The effect is in the direction of high key, though not that extreme.

SHAKER SHIRT

Two versions of a white Shaker shirt hanging on a rail against a white wall. "White on white" is usually a possible candidate for high-key exposure, as we just saw, and for the same reasons it is also possible to treat it in a less extreme way, with an exposure increase in the order of 1/2 to 1 stop. The difference here is 2/3 stop.

Fast-track & Foolproof

Technical

The Twelve

STYLE

135

Post-processing

Reference

Flare

Flare is an artifact, in that it is non-image forming light. It also takes more forms than many people realize, from lines of polygons to halation.

Most flare is optical, caused by light interacting with the surfaces of lens elements and internal structures inside the lens barrel, such as the aperture diaphragm and barrel walls. It is a direct result of shooting toward a light source, exaggerated by having a wide aperture and a full exposure. In addition, the sensor itself can contribute to flare in the form of blooming, which happens when individual photosites reach their full well capacity (see pages 20–21 *Light on the Sensor*) and begin overflowing their charge into their neighbors. Flare can affect the entire frame or just a small area close to the brightest light in the shot. It can appear as a generalized loss of contrast and increase in brightness, or as streaks from dirt and grease on the glass, or specific shapes—polygons of different colors related to the aperture blades.

The usual response to potential flare is to avoid it, and there are a number of practical things you can do. These include using a lens shade, shading the lens more precisely with a

MOUNTAIN AIR

In this shot of Iceberg Lake in Glacier National Park, Montana, there is a very distinct and deliberate use of flare. The polygon stripe adds a useful diagonal component to the composition, and the halation around the sun produces an atmosphere of bright mountain air.

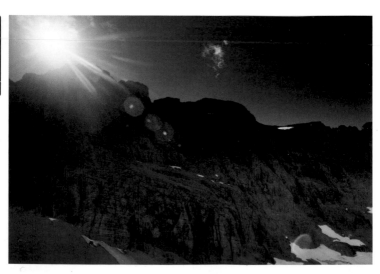

flag or even your hand held far in front, keeping lens surfaces spotlessly clean, choosing a viewpoint that avoids shooting into the light source, and positioning so that an obstruction hides the light source. Lens-manufacturing technology also employs sophisticated coatings to help reduce flare.

Nevertheless, flare can be put to creative use, both for its graphic effect and for the sense of actuality that it can give. Whether or not the graphic effect works depends on personal taste. The actuality argument is that because flare is an artifact that you would avoid on technical grounds, it adds to the realism by suggesting a hurriedly taken shot. Movie special effects make frequent use of artificially computed flare for this very reason.

SHAKER WINDOW FLARE

Flare in this Shaker Ministry room at Pleasant Hill, Kentucky, surrounds the window frame, while the view through to the exterior is grossly overexposed. Nevertheless, this is what I wanted, rather than a technically perfect, flare-free image, which with multiple exposures would have been possible. Indeed, this was the image chosen for the cover of the first major illustrated book published on Shaker communities and crafts.

REFLECTED FLARE

A subtle but noticeable halation suffuses this into-the-light shot with a fogginess that affects the shadow areas of the boats. The sun and its reflection in the Mekong River at Phnom Penh in Cambodia are just out of frame, but the light striking the lens adds a veil of lightness. In post-processing it would be easy to "correct" this by tightening up the black point, but that would lose the point of the image and the atmosphere it evokes.

Fast-track & Foolproof

Technical

The Twelve

STYLE

137

Post-processing

Reference

Highlight Glow

Most of the kinds of flare that we just looked at involve overexposure, simply because the usual cause is shooting toward a light source.

In addition to whatever other image artifacts it might create, flare almost always involves halation—the creation of a halo or glow around the light source. This is by no means a bad thing, and gives a kind of atmosphere to the shot. However, for this flare-associated glow to work well, it needs to grade smoothly into the clipped area. Film, backed up by our own visual perception, records this highlight glow smoothly—an effect known as roll-off.

This allows overexposure to be a reasonably pleasant visual experience. Digital imaging's abrupt cut-off at the top end of the

scale is what causes the majority of highlight problems, and a typical result is a sharp edge or band around the highlight. Cameras vary in how well they handle this banding, and the curve applied during the camera's processing to the original linear image can help. Even so, it may be necessary to do post-production work on this kind of area, by applying a controlled blur on a selection.

The other solution is to try to eliminate glow, and with a still scene and a fixed camera, shooting an exposure sequence means that HDR tone-mapping can be used. Some tone-mapping operators work at reducing the flare-like effect.

NEON LIGHTING

Neon display lighting can react in unexpected ways to being photographed, because of its discontinuous spectrum. In this Beijing apartment, Chinese characters form a display along one wall, and I used this one, spelling "Revolution," in a composition taking in part of a corridor.

The problem was to maintain both the color as it appeared to the eye (red) and the glow that it gave off. Without glow, the neon would lose its character as a light source. Different exposures and careful post-processing produced the final effect.

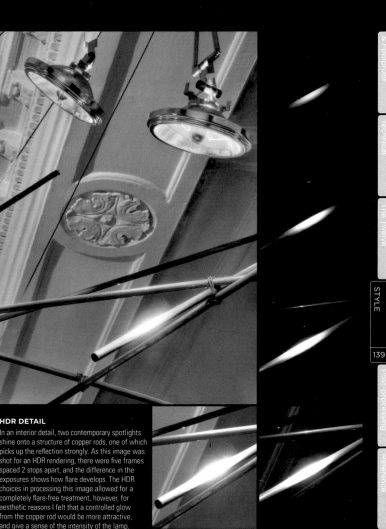

Fast-track
& Foolproof

Technical

The Twelve

STYLE

139

Post-processing

Reference

HDR DETAIL

In an interior detail, two contemporary spotlights
shine onto a structure of copper rods, one of which
picks up the reflection strongly. As this image was
shot for an HDR rendering, there were five frames
spaced 2 stops apart, and the difference in the
exposures shows how flare develops. The HDR
choices in processing this image allowed for a
completely flare-free treatment, however, for
aesthetic reasons I felt that a controlled glow
from the copper rod would be more attractive,
and give a sense of the intensity of the lamp.

Low Key

Just as high key images occupy the upper end of the brightness range, so low key falls into the darker, shadow bracket—but with a difference.

For reasons that may be psychological, it is more difficult to make a successful, coherent image composed entirely of dark tones than it is of light tones. Simply lowering the exposure to make the image darker, and therefore low key, is never the entire answer. There has to be a reason for the scene to be rendered dark, otherwise it will be regarded by most viewers as a technical mistake—and they would probably be right.

One valid reason is to communicate dusk or night, another the sense of a gathering storm or massively overcast weather. In either of these cases, it's important to consider the textural qualities as well as the tonal. With less mid-tone detail than usual, dark areas of the image derive their interest from quite subtle

DUSK TREE
Here is a more traditional reason for working in low key. This is dusk in Kensington, London, and two versions show the difference between deciding exposure on automatic or more thoughtful grounds. The brighter version is averagely exposed, and reveals everything fully. However, it looks less like the evening view than the darker version.

$^1/_{30}$ SEC, f2

$^1/_{30}$ SEC, f1.4

ORIGINAL

LOW KEY

modulations. This, together with the possibility of rich blacks and very fine separation between dark tones, makes these kinds of low-key images very rewarding for fine-print making. Some traditional processes, notably platinum printing, can handle such images with great delicacy and assurance. In color photography, this is lacking somewhat, but one compensation is the chance to explore rich, dense colors that are out of the usual range of experience.

REDUCING DETAIL

As seen, the Angkor ruin of Bayon in Cambodia, bathed in afternoon sunlight, showed more detail than I wanted, and I felt it had much better potential as a low-key image with a brooding atmosphere. Accordingly, it was processed as black-and-white, darker and with lower contrast.

Fast-track & Foolproof

Technical

The Twelve

STYLE

141

Post processing

Reference

In Praise of Shadows

The title *In Praise of Shadows* is stolen from an influential essay by Junichiro Tanizaki, written in the 1930s. In it he railed against the new tendency to install tungsten lighting in traditionally dark Japanese interiors, but the point is not completely alien to photography.

In digital processing there is a tendency to choose auto—with its generic brightness—without thinking; but it doesn't have to be that way.

In addition to the logic on the previous pages for justifying low key is the personal, but entirely valid, preference for dark images. I'm sure that the materials in different kinds of photography have had their influence here. Kodachrome color slide film, for example, had a tremendous influence in numerous ways for many years. Practically, slide films bear much resemblance to digital imaging in that they have a less than ideal dynamic range and look terrible when overexposed. Because of this the cardinal rule for professionals shooting slide film—and most did because magazine color printing was geared to slides—was to err on the side of underexposure. Kodachrome, with its unique silver-based chemistry, reacted to this treatment in a special way. Great detail, more than many people would suspect, was kept in the shadows, and when the repro house or printers got hold of it, they could successfully open up these shadows.

GLOOMY WEATHER

Early morning rain clouds flow over the mountains in this remote part of the Venezuelan Andes, which prompted a reduced exposure to reveal the range of grays in the sky. However, I was also very drawn to the sense of the white buildings just emerging from darkness, as it seemed to reinforce the feeling of isolation.

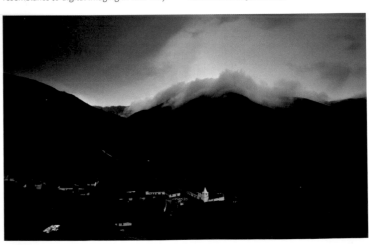

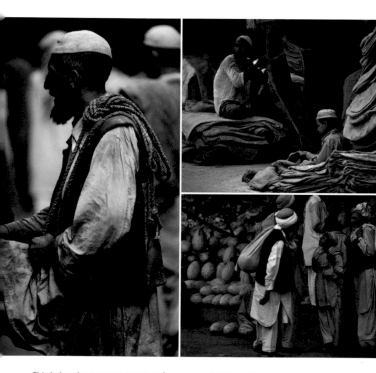

Fast-track & Foolproof

Technical

The Twelve

STYLE

143

Post-processing

Reference

This led to the common practice of photographers overrating Kodachrome by around a third of a stop—and sometimes even more. I'm convinced this, in turn, encouraged a culture of the dark, rich image, and many professionals came to like the restraint and subtlety of what were essentially low-key images. The images here attempt to show what I mean by this. It is a matter of taste, but I like the somber and dark colors of the North West Frontier that I photographed many years ago. These images are on Kodachrome, but they have been scanned

LIFE IN PAKISTAN

Scenes from Pathan life in the bazaar and streets of Peshawar, the chief city of Pakistan's North West Frontier provinces. In each case I worked deliberately in a lower tonal register that seemed to me to suit the subject, as described in the text.

carefully to retain the low key. The dirt, ash, and general lack of color created a special atmosphere that I wanted to keep. Brightening the scenes and their attendant colors would have been easy, and tempting for some, but not for me.

Deep Shadow Choices

Going further into the idea of subduing exposure for reasons of style, you can be selective about which part of the tonal range you choose to keep dark.

In the examples on the previous pages, the entire range was considered and reduced in brightness. However, some scenes contain large, or at least important, shadow areas, and this tends to focus exposure decisions more on this lower end of the scale. In particular, the decisions tend to be about how much these will reveal, and how far down into the shadow scale you expect to see detail.

Shadow areas behave very differently from highlights in the way that they are recorded digitally, principally in that there is a much more gentle roll-off. Even if you under-expose grossly there are still usually a few photons striking the sensor, so deep tonal values often hover a few levels above zero, even though by eye they may be difficult to distinguish from solid black.

Also, we perceive shadows in a different way from highlights, even though the loss of detail this far in distance from the mid-tones is similar. Compare, for example, the top and bottom 10% brightness in almost any photograph with a full range, as in the example here. Highlights carry a sense of glare, while shadows are areas we tend to peer into. This is a perceptual matter: if the highlights are rendered so that we think of them as bright, we take them in but tend not to spend time on them; with shadows, if we think they have some relevance we look longer at them to discover detail.

Keeping shadows deep retains this sense. Indeed, revealing everything is rarely a good idea, though unfortunately this is becoming the default in digital processing. All the tools are there to recover detail, and this encourages many people to use them, which is a definite case of technology intervening in the creative process for the worse.

FRONTIER LAND
About 40% of the area of this image, on the North West Frontier of Pakistan, is shadow area, and given the contrast between land and sky, and the decision to treat this darker as a pre-sunrise scene, the darkest area around the rocks will inevitably be very dark. Ultimately this is a matter of taste.

HIGHLIGHTS AND SHADOWS

Isolating the deep shadows and the bright highlights (in each case the extreme 10% of the tonal range) emphasizes the difference in the way we normally look at detail within them. The shadow areas are the ones that encourage more examination, while the highlights tend to get simply a glance.

SCULPTURE SEQUENCE

This black sculpture below, photographed in bright, clear sunlight, presents difficult choices in the treatment of the main upper area. Opening up the exposure, which is limited by the danger of highlight clipping on the bright lower part, has the effect of broadening the edge in from the outline in which detail can be seen. Each exposure is one stop different from the next.

EV -1 **EV** **EV +1** **EV +2**

Fast-track & Foolproof

Technical

The Twelve

STYLE

145

Post-processing

Reference

Another Kind of Low Key

A completely different type of low key is created by stark and limited lighting from a single source to one side, and this inevitably gives the image a High Dynamic Range, although very skewed as any histogram will show.

Edge-lit subjects, which are so specific that they warrant being a lighting type all on their own (see pages 92–97), are potentially one kind of low-key shot, and an important variety at that. I say potentially, because raising the exposure changes the character

of the shot, as does adding fill. This kind of low key is usually discussed as a studio lighting technique, and not so often as found lighting in real, uncontrolled situations. The technical conditions are a single key light, typically from behind the subject and off-axis, with little or no fill. In studio terminology, the key-to-fill ratio (that is, the brightness ratio between the main light and whatever is used to fill the shadows opposite) is very high, such as 8:1, in comparison to a "normal" lighting set that might be between 3:1 and 1:1.

DARTH VADER'S HELMET

Overhead lighting from a square diffused window flash head, with a silver foil reflector below provide the modeling and establish the glossy texture of Darth Vader's iconic helmet in the props store of the film studio ILM, but the essential presentation is black on black. This is one of the basic low-key studio lighting styles.

Fast-track & Foolproof

Technical

The Twelve

STYLE

147

Post-processing

Reference

Low-key edge lighting is not at all common outside the studio, but this is precisely what makes it interesting, and also challenging for calculating the exposure. The circumstances needed—rear off-axis hard light falling on a subject otherwise in shadow—are always localized, and this adds another challenge in documentary photography. Direct sunlight through a gap or slit is one such situation. Any moving subject passing through this kind of lighting, such as a person, will often be in position in the shot for only an instant, which gives no time to adjust exposure. You need to know in advance what the settings are, and get them right first time. One saving grace is that edge-lit shots can work at different exposures, albeit each giving a different impression. If you over-expose, you lose the low-key effect, but the extra information in the shadows can compensate for the flared, blown edge

PERU

To the eye, this interior of a Peruvian cafe revealed more shadow detail than was kept in the image. The combination of camera angle and single light source from in front and to the left (the open doorway) was sufficient to edge-light or silhouette the key shapes. The men, table, harp, and flagstones all communicate clearly with the minimum of detail, another characteristic of low-key lighting.

highlights. That's fine if you are happy to accept the surprise about which of these you get, but to capture exactly the image you envisioned in this kind of lighting, in a real-life situation, is a mark of real skill.

It's easy to make too much of the emotional content of a photograph simply through its lighting, but low-key images often do tend to express some mystery, threat, gloom, or melancholy. Not for nothing was low key a common technique in film noir.

Silhouette

One special option for dealing with a dark subject that is in contrast with a light background is to create a silhouette.

A silhouette, which should be familiar to everyone, is by its nature black, and provided it fulfils the necessary criteria has no need to carry any shadow detail at all. This very specific graphic representation had its origins before photography, often as cut-out black paper. It was a cheap art-form that became popular in the 18th century. The appeal, and the skill, of these silhouettes lay in creating recognizable forms, and even extracting personality from simply an outline. In this sense, the silhouette had much in common with the cartoon, drawing out essential characteristics by simple means. Although at first glance all of this may seem far removed from calculating the exposure for a photograph, the interesting thing is how silhouettes have come to be almost solely the province of photography.

One of the reasons that silhouettes are popular in photography is that the dynamic range problem of contrasty scenes is equally relevant to film and to digital imaging. Backlit situations are so commonly out of range that a silhouette treatment, reducing the exposure so that everything within the outline is solid black, makes perfect sense. Another reason is the pleasure of surprise in discovering how a subject looks when reduced to an outline. One of the things that you quickly learn when trying to compose a silhouette shot is that only some viewpoints work graphically, in the sense of showing clearly what the subject is, and also in the sense of being interesting. Faces, for example, tend to work best in

TIBETAN PILGRIMS
On the edge of easy readability, this shot of Tibetan pilgrims crossing a high mountain pass would have been a little more obvious if the faces had been in profile and if a hand had been visible, but also possibly less interesting. When the shadow and lit areas (subject and background) are close to each other in area, images acquire the ambivalence of figure-ground relationships —a momentary confusion of which is which.

FRACTION OF AN F-STOP

A ⅔ stop difference in exposure here makes a marked difference in this potentially silhouetted view of a Vietnamese monk repairing a temple roof. The fuller exposure reveals some detail in his robes, while ⅔ stop darker reduces the image to outline only. My preference was for the silhouette treatment, but you could argue either way.

profile. Figures are a little more complicated, and the way in which limbs cross when in action, for example, makes a great difference to the readability of an image.

VIEWFINDER PAIR

Images suitable for silhouette treatment usually offer the alternative choice of an exposure that shows shadow detail. One useful way of deciding which way to go with the exposure, so long as the aperture is small, is to press and release the camera's depth-of-field preview button. The on-off darkening-lightening helps to show whether the image will work in outline.

Irrelevant Highlights and Shadows

Often there are times when it is simply not worth worrying about whether certain highlights should or will hold, or what is going on in the deepest shadow areas. Clipping, which so much of the time is presented as the great evil of digital exposure, may not always matter.

These are the two extremes of the tonal range in a scene with a full dynamic range, and they behave differently, not only in the way the sensor records them but also perceptually. As we have seen, highlights clip decisively, so in a bright area that should grade smoothly toward overexposure, such as the halo around the sun, there is usually a distinct edge—a form of banding. With the darkest shadows, however, in an area that shades to total black there are usually some lingering very low values, around 1 or 2 on the 0–255 scale, as the sensor picks up stray photons. Also, perceptually we pay much more attention to bright areas than to dark. Bright highlights are simply more noticeable than dark shadows, and this is helped even more by the difficulty of getting good separation of deep shadow tones when printing on many inkjet papers.

There are two situations in which the highlights ceases to be important. One is when the highlights are extremely small,

and the other is when a light source is in shot—sometimes. With point sources of light, such as street lamps or the sun in a wide-angle shot, the small size also comes into it, and it is usually acceptable for these to be blown out because the light sources are perceived as being normally too bright to look at directly.

Because shadow clipping is much less obvious to the eye, especially in a print, it is less of a serious issue and there is more latitude. What matters is the context of other, lighter neighboring shadow tones.

SHADOW CLIPPING
The shadow area shades do vary, as indicated by the tonal values shown. Visually, there is little to distinguish at first glance between 10 and 0, but even close inspection reveals no difference between 5 and 0. This makes shadow clipping less of a problem than highlight clipping. In brackets are the brightness percentages. The image is shown desaturated to avoid the complication of different tonal values between Red, Green, and Blue channels.

Fast-track
& Foolproof

Technical

The Twelve

STYLE

151

Post-processing

Reference

CLIPPED LIGHT

Simply by virtue of small size in the frame, these light sources appear perfectly acceptable when clipped. Note that the halo surrounding each helps this.

REFLECTION AND REFRACTION

Specular highlights are reflected light sources that are particularly common in shiny convex surfaces, which render them as virtually points. Here, small raindrops reflect and refract the sun.

Brightness and Attention

In certain kinds of image, the exposure, by controlling the brightness, also determines how a viewer's eye travels around the frame and what it focuses on.

There's no great surprise in this, given that the HVS pays particular attention to brighter areas and also to the contrast between light and dark. In a situation that has a brighter area *emerging* from dark surroundings, however, it has a special relevance when choosing the exact exposure settings. The landscape shown here is a good illustration of this, and I'm using the term "emerging" in the sense that there is a gradation through the frame from dark at the edges to light in the center. Varying the exposure alters the area that is visible and readable. The usual vignetting from the wide-angle lens used (20 mm) adds to this effect.

The second part of the equation is that there is some latitude for choosing the

exposure. Clearly, highlight clipping in any situation like this is a main concern, but even when staying within this upper limit there is a valid choice. In this example, the choice is in the order of 1 to 2 stops. The standard exposure would be one that keeps the center as bright as possible without clipping, but there are very good reasons why in this case I preferred a shorter exposure. One was that I wanted the sky colors rich, and I also wanted a sense of the world emerging from darkness, in the pre-dawn. There was also a third reason, which was to concentrate the attention on a relatively small area of the frame in a natural way, without resorting to filters or a frame-within-a-frame viewpoint or manipulation.

These are particular lighting circumstances, but not all that unusual. Much more common is when a patch of light is cast through an opening, like a window, with a more hard-edged division between light and

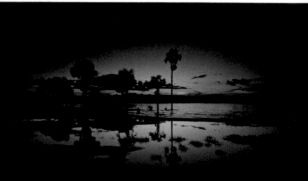

shade. The second image illustrates this. Again, so long as there is some latitude for choosing the exposure, a darker treatment will close off the shadows more and prevent attention from straying away from the lit area. This is useful if you want to control and limit the viewer's attention in this way, which I did in this example. In any case, the way in which someone else will look at the image and what they will pay attention to is always something to consider in this kind of situation.

SUNLIGHT AND SHADOW
Late afternoon sunlight shining between stone balusters in a gallery of Angkor Wat, Cambodia, onto a pair of bas-relief apsaras, or celestial dancers. The coincidence of spacing combined with the undulating outline of the balusters made the shot worthwhile, and it was then a matter of waiting several minutes for the passage of the sun to fit the shadows precisely to the carvings. A fuller exposure here would have been less unusual and less graphic, by revealing shadow detail. I preferred this treatment, and indeed did not shoot any other version.

Fast-track & Foolproof

Technical

The Twelve

STYLE

153

Post-processing

Reference

²/3 STOP DARKER

POST-PROCESSING

In a way, I would rather *not* talk about processing in this book, and instead concentrate solely on getting the exposure right at the start—right for the conditions and right for you, the person taking the picture.

Fast-track & Foolproof

Technical

The Twelve

Style

POST-PROCESSING

155

Reference

Processing and post-production are often, and maybe too often, used to sort out issues that should rightly have been taken care of at the moment of shooting. However, realistically, it's impossible to divorce digital shooting completely from digital processing, at least when shooting Raw.

Digital processing is a booming branch of software development. Feature upon feature is constantly being added to what is on offer,

to the point where the choice verges on the bewildering. The leading software packages used by photographers, such as Photoshop, Lightroom, LightZone, Aperture, DxO Optics Pro, and Capture One, as well as the individual camera manufacturers' software, are already awash with sliders and presets. Competitors try to outdo each other, while the teams working on updated versions try to outdo themselves. The result is now more ways of processing a single image file than any normal person could hold in mind at once.

This is good from the point of view of potential. If you are prepared to put in the time, you can tweak, control, fine-tune, or however you like to put it, to an infinity of results, but it's not so good for encouraging the basic skills of shooting. There is a growing belief that digital processing can solve everything, and I suspect this encourages a number of people to be sloppy with their camerawork. The reality is that sophisticated processing techniques work best with well-exposed image files. No surprise there, but far from software being a crutch to support poor photography skills, I think I can convincingly argue that the progress in all this software actually calls for more accurate exposure. To get the most out of digital processing, you should have the maximum information and quality in the original files. The idea, after all, is to step final image quality up, not just perform feats of recovery.

PROCESSING EXTRAS

Punch, contrast and vibrance were added to this shot by using now-standard tools in typical Raw processing software.

EXPOSURE SEQUENCE

You can shoot a static subject even handheld at a range of exposures, and then later combine them either by exposure blending or HDR techniques.

Choosing Exposure Later

The core argument for shooting Raw is that with most images it gives some exposure latitude. From the point of view of traditional photography this really is a novel idea—that the exposure "condition" of an image is no longer fixed at the moment you squeeze the shutter release.

Does this invalidate the importance of getting the exposure exactly as you want it? The answer is, not at all. The perfect exposure for a particular image, and a particular photographer, will always give the best image quality in the form of smooth progression of tones, freedom from noise, and holding detail at the high and low ends. The difference is that the extra bit depth from a Raw file makes it a cushion for error, or to be more polite about it, as a cushion that allows you to reconsider the nuances of exposure later, when you have more time and when you might have changed your opinion about what works best.

It's important to deflate any wild expectations about just how much you can choose the exposure at this stage rather than when shooting. In theory, this higher bit depth can give a four stop range to play with, but this is just the capability of the extra bit depth and it is limited by the performance of the sensor.

The key question, then, is how much latitude Raw gives you, and the answer is not straightforward. Rather, it depends on the scene, the sensor and on how accurate your exposure was in the first place. What confuses the situation is the bit depth, or rather, the different bit depths, because most camera sensors capture either 12-bits per channel or 14-bits, while image-editing software imports this as 16-bits. This does not mean that Raw files carry a full 16-bit range, which would be an exposure latitude of 8 stops more than 8-bits. It just means that the potential for exposure latitude is there. Currently, a good DSLR used in ideal conditions will offer an effective exposure latitude of around one or two stops more when shooting 14-bit Raw than when shooting 8-bit TIFF. The latitude cannot be quantified precisely, because what may be acceptable noise or loss of detail at the ends of the scale for one photographer may not be acceptable to another.

DEFAULT

An unedited shot taken on the South Bank of the River Thames, facing Tower Bridge in London, before being opened in these different tools.

ADOBE CAMERA RAW

A scene typically exposed to hold the highlights often results in apparent underexposure. The several sliders in a Raw converter, here Photoshop's ACR, offer many ways of interpreting the exposure.

CAPTURE ONE PRO
Phase One's Capture One Pro is a fully featured Raw conversion tool, showing this view on opening the file.

DXO OPTICS PRO
The default interpretation of DxO Optics Pro, a tool that allows for exposure compensation and lighting adjustments.

LIGHTROOM
The same Adobe Camera Raw converter is embedded in Lightroom, an image processing tool aimed specifically at photographers and combined with database functions.

LIGHTZONE
Here is the image as seen in LightZone, an image-editing program that also contains a Raw converter with Exposure, Color Noise, Temperature, and Tint options.

Fast-track & Foolproof

Technical

The Twelve

Style

POST-PROCESSING

157

Reference

Exposure, Brightness, and Lightness

Probably the greatest value of Raw shooting from the point of view of exposure is that the extra bit depth, 12- or 14-bit as captured, and 16-bit as converted into the image-editing software, allows the actual exposure to be adjusted to a degree.

I say "actual" to distinguish this from the frankly spurious "exposure" adjustments offered in TIFF- and JPEG-editing methods, such as the post-processing controls described later in this book. "Exposure" adjustment in post-processing is an attempt to replicate the effect, and it is valuable for this, but it is better not to confuse it with "real" exposure control.

ORIGINAL
Brightness/Exposure not adjusted.

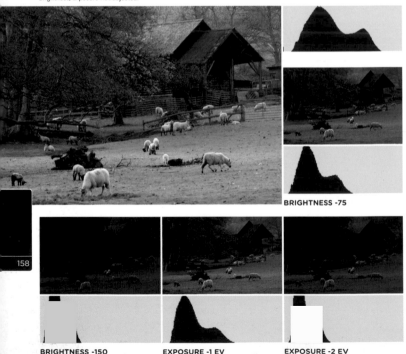

BRIGHTNESS -75

BRIGHTNESS -150 **EXPOSURE -1 EV** **EXPOSURE -2 EV**

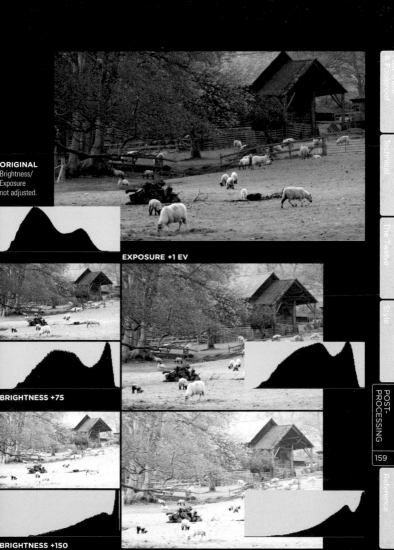

ORIGINAL
Brightness/
Exposure
not adjusted.

EXPOSURE +1 EV

BRIGHTNESS +75

BRIGHTNESS +150

EXPOSURE +2 EV

Fast-track & Foolproof

Technical

The Twelve

Style

POST-PROCESSING

159

Reference

Here I want to look at the controls available in Raw processing, which extend beyond the exposure latitude that we just looked at on the previous pages. The effect of controls labeled "exposure," "brightness," and "lightness" are similar in general effect, but they are different in subtle ways. As always with imaging software, beware of the labels, because they may not mean what you think they should. Sometimes, software developers have strange ideas about meaning.

ORIGINAL

RAW BRIGHTNESS
In this image, the brightness was adjusted using the Raw conversion software.

IMAGE EDITING BRIGHTNESS
In this image, the brightness was adjusted using the image-editing software.

RAW EXPOSURE

In this image, the exposure was adjusted using the Raw conversion software.

EXPOSURE

In this image, the exposure was adjusted using the image-editing software.

RAW LAB LIGHTNESS

In this image, the lightness was adjusted using the LAB slider.

POST LIGHTNESS

In this image, the lightness was adjusted using the post-processing software.

Fast-track
& Foolproof

Technical

The Twelve

Style

Reference

Selective Exposure

The current trend in editing software is to move more and more adjustment tools into the Raw converter, so that in most cases photographs shot in Raw can be processed completely in one session, without then having to do more work on the TIFF file.

As part of this trend, the major programs, including Photoshop, Lightroom, and Aperture, now include in their Raw editing suites the means of selectively increasing or decreasing exposure. These include highlight recovery and shadow fill, contrast (both global and local), vibrancy, and clarity. Highlight recovery, shown here in an example, takes advantage of the fact that highlight clipping due to overexposure occurs at different points for each of the three color channels. It works by reconstructing tonal values in a clipped channel by using the information in another color channel.

Contrast, in particular, has a valuable effect on the appearance of exposure, especially with the relatively new tools controlling local contrast—tone-mapping operators. One thing that digital post-processing has made relevant is the spatial range of contrast. Another way of putting it is that the contrast across a particular area of the image may well be, and often is, different from the contrast across the entire picture. Some people invoke a comparison with wet-darkroom dodging and burning, but this is not the same thing. In dodging and burning, local areas are either lightened or darkened whereas, in local tone-mapping, the values of pixels are adjusted up or down according to their neighbors, and the effect is that contrast is adjusted locally. In the software, there is often a radius slider, and this alters the size of the area that is affected.

HIGHLIGHT RECOVERY
Highlight recovery is one important form of selective adjustment, also in Raw conversion. Here is Photoshop's Raw converter in action, with subtle but valuable restoration of the blown highlights at the upper right using the Recovery slider. The far right image is adjusted to 100% to restore highlights: Note that this high setting also affects midtones, which may or may not be a good thing. The red area is the highlight clipping warning,

BEFORE

AREA CHOSEN

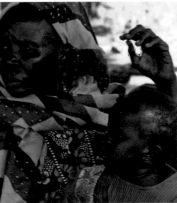

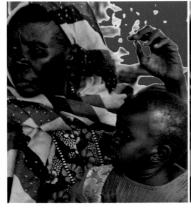

Fast-track & Foolproof

Technical

The Twelve

Style

POST-PROCESSING

163

Reference

LIGHTROOM ADJUSTMENT BRUSH

Lightroom's selective controls use what is called an Adjustment Brush. Opening this enables a range of slider adjustments that include Exposure and Brightness, and the effect chosen—here mainly a reduced exposure with some increase in contrast and clarity—can then be applied to any area. In this case, the brush is used to selectively darken the sunlit parts of the street, buildings, and sky.

1. The Adjustment Brush is selected, its size and feathering set, and the estimated adjustments chosen.
2. The first stroke of the brush applies the chosen settings.
3. After this, the mode switches to Edit, and sliders can be used to refine the effect; in this case decreasing the exposure further.

EXPOSURE ADJUSTED

RESULT

Post Exposure Control

As much as I'm trying to avoid getting stuck in specific software, Photoshop's Exposure control under Adjustments deserves special attention, because it promises a kind of non-Raw exposure adjustment. It works on TIFFs and JPEGs, but it cannot deliver real exposure adjustment in the way that a Raw converter can.

What it does offer, though, is sufficient control to mimic the effect, which can be useful for recovering mistakes, with apparently similar results where possible. It is also good for working on images that were captured as TIFFs or JPEGs, or captured as scans from film. Other than that, it does not really belong in this book, but I am covering it for the sake of being thorough. The important

caveat, therefore, is that this is not an exposure control, but it can produce results that give that appearance.

The Exposure dialog offers three slider controls, which, though not especially intuitive, make a sensible attempt at allowing the user separate control over highlights,

ORIGINAL IMAGE
Some adjustments were made in Adobe Camera Raw, then the image was imported into Photoshop.

164

shadows, and contrast. As is increasingly common with imaging software, developers use terms to suit themselves rather than to stay true to the original meaning. The Exposure slider in this case strongly affects the highlight end of the scale with, as Adobe puts it, "minimal effect in the extreme shadows." If you look at the effect illustrated on the following pages, you can see the histogram at Exposure minus one moves very little at the left side, but is squeezed in from the right (the highlight end).

The next slider, Offset, does indeed offset the shadows. This is intended by Adobe to darken the shadows and midtones with "minimal effect on the highlights." So,

increasing the Offset alone, which you would not normally have any reason to do, moves the entire shadow limit to the right, but leaves the right (highlight) end more or less unchanged. This is the opposite of closing in the black point in normal processing. Lowering the Offset strengthens the shadows in a way similar to closing in the black point.

The Gamma control does as all gamma sliders do, which is to use a simple power function that affects brightness and contrast. Here it is used for its contrast effect, although

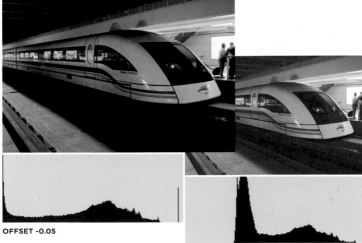

OFFSET -0.05

OFFSET +0.05

this is inseparable from its brightening/
darkening effect. Sliding to the left weakens
contrast and lightens, and is the equivalent of
lowering the slope of the center of the tonal
curve. Sliding to the right strengthens
contrast and darkens, which is the equivalent
of increasing the slope of the curve.

The way to use the Exposure control as a
means of altering brightness and contrast in
a photo-realistic way is to use the sliders from

GAMMA 1.6

GAMMA 0.6

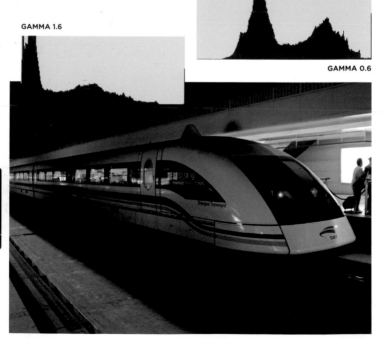

the top down. Begin with Exposure, then slightly alter Offset, either to strengthen shadows or open them up, and finally move the Gamma to improve contrast to taste.

PHOTOSHOP EXPOSURE

The Exposure tool makes adjustments to the apparent exposure of the image, measured in stops. The Offset adjusts the shadows independently and the Gamma affects the contrast.

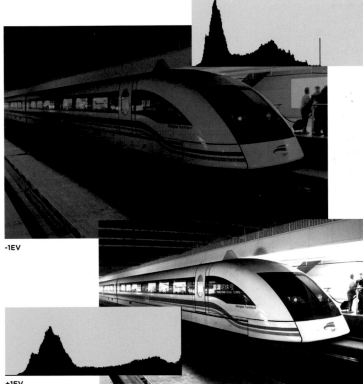

-1EV

+1EV

Fast-track & Foolproof

Technical

The Twelve

Style

POST-PROCESSING

167

Reference

HDR Imaging

High Dynamic Range (HDR) imaging has developed from a highly specialized area of computer graphics in the motion-picture industry into still photography in a short period of time.

The processes are by no means perfected, but it is extremely useful for the photography of high-range scenes—and very relevant indeed to exposure. The computing complexity involved in HDR imaging makes it look daunting, although it doesn't have to be. For photographers who are committed to the importance of shooting rather than messing around with software, it may seem too much and too artificial, but I would argue that the principle is photographically pure. It is an answer of sorts to the constant problem of dealing with high-range scenes using low-range camera sensors.

No current camera sensor can handle the full range of brightness in the kind of high-range scene that takes in, for example, the sun itself and deep, enclosed shadows. We've already looked at this in many ways in this book. However, a sequence of exposures, varying the shutter speed without moving the camera, can easily cover any range. The problem is that these different exposures are each on different frames—in separate image files. Along comes the first part of the HDR process, combining these into a single image file. This is relatively simple and extremely easy for users.

IMAGE SEQUENCE FOR HDR

This sequence of exposures was actually hand-held because I was in too much of a hurry to catch the light to go for the tripod. I was confident, nevertheless, that the software alignment function would work. There is a one stop difference between each. The bracketed sequence was shot automatically, and the camera does this by shooting first an averagely exposed frame, followed by a sequence from darkest to lightest.

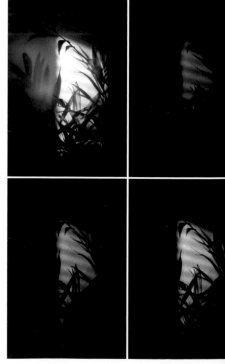

There are by now a number of HDR image file formats, including a kind of TIFF, that will hold all the exposure information from a number of frames. There are also several makes of software that will do it for you automatically, including Photoshop and a dedicated application, Photomatix Pro.

FINAL HDR (BOTTOM RIGHT)
My final choice of a tone-mapped HDR image, using Photomatix Pro. As the sequences illustrate, there is almost endless room for choice of effect.

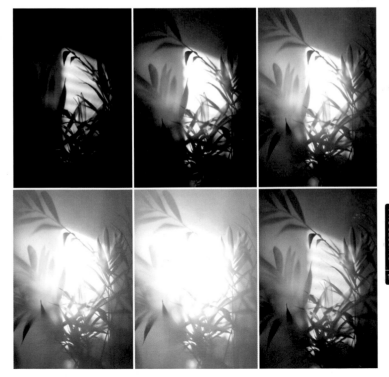

Fast-track & Foolproof

Technical

The Twelve

Style

POST-PROCESSING

169

Reference

32-BIT PREVIEW

If you convert using Photoshop, the first stage is to see a 32-bit preview. Alongside thumbnails of all your source images, arranged according to Exposure Value, you'll see a histogram with a slider. The slider alters the (by its nature) low dynamic range on-screen preview, but does not affect the image.

Shooting and combining an HDR sequence is not complicated. The problem, however, is that you cannot view it! With an HDR file we have simply transferred the high-range scene faithfully without tackling the issue of making sense of it as a viewable photograph. It is not just the limitations of the camera sensor that come into play, but also the similar range limitations of a standard monitor and the even greater limitations of paper for printing.

The solution is somehow to compress the range contained in the HDR file to that of a normal image file, meaning 8-bits per color

channel. This is still work in progress and the perfect process has yet to be invented. Meanwhile, there are a number of very ingenious methods in the form of tone-mapping algorithms. The math here is complex, and while no one expects photographers to follow it, the competing processes can be frustratingly opaque in the sense of understanding them and predicting their results. But as one of the solutions for dealing with some difficult exposure situations it is unavoidable. At the very least, when the situation allows multi-shooting and it is convenient, I strongly recommend it.

HDR CONVERSION

To begin the conversion, click Image > Mode > 16-bit. This selects the highest Low Dynamic Range mode, so the image must be converted using one of the four available methods; a basic Exposure and Gamma adjustment; Highlight Compression, which is not much use in this example; Equalize Histogram; and a local tone-mapping operator called Local Adaptation, which is based on a bilateral filter with an added tone curve for fine adjustment.

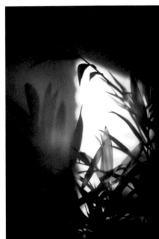

Fast-track & Foolproof

Technical

The Twelve

Style

POST-PROCESSING

171

Reference

LOCAL ADAPTATION

This method allows you to make adjustments to the toning curve and to the Radius and Threshold of the effect, which is applied regionally. Here the Radius has been reduced to 10 px and the threshold increased to 0.63. The tweaked curve applies a stronger effect to the darker areas of the image.

EQUALIZE HISTOGRAM

Again there are no options with this conversion method, though the result is a little more interesting in this case.

HIGHLIGHT COMPRESSION

There are no options associated with this conversion method, and, as you can see, it is of little use with this subject.

BEFORE MERGING
The HDR software displays a small preview window over a complete image which cannot show all the tones on screen. The preview is processed "on the fly" according to the selected settings.

This may be late in the book to raise such a fundamental matter, but HDR imaging does trigger a special question. One complex perceptual issue that is still not fully tackled is what is expected from a photograph. In the sense of how realistic it should look, this is not something that has come up in any major way through traditional photography. HDR and exposure blending techniques, added to increasingly sophisticated Raw processing, now make it possible to make images that look any way you like.

Most of the HDR tone-mapping work has gone into compressing all that wide tonal information into a viewable image in such a way that everything is readable at once. In a way, this is an attempt to mimic human vision, but human vision works in quite a different way from photographic imaging, and how we look at a scene also differs from how we look at a photograph of the same scene.

The usual response from people working in HDR imaging is that we need to translate the experience of seeing something with our eyes into a flat, bounded photographic image. Yet this doesn't go far enough. The photograph itself is not the end of the line; rather it's how we look at the photograph. All the complexities and mechanisms of human perception are still being put to work; it's just that we are looking

at a different object. One of the major leaps in the study of the HVS was to understand that we construct an intelligible image from limited sensory input, and to do this the HVS uses a variety of means, not all of them yet fully understood. They include expectations based on experience. In a similar way, when we look at a photograph there are certain things we expect, mainly built up from many

years of looking at photographs and having them a part of our daily lives.

Most people are surprisingly alert to the overall "realistic" appearance of a photograph. By this I mean whether or not it was made with a camera and not messed around with. This is extraordinarily difficult to define, yet most visually aware people, and certainly photographers, can spot "enhancement" a mile off. Many people indeed like the difference that comes from departing from photo-realism. Nevertheless, it remains a departure, and owes its existence to being compared with the perceived correctness of a "true and pure" photograph.

PHOTOMATIX

The sequence using Photomatix software. At the tone-mapping stage, two different methods are offered: Details Enhancer, which is a local tone-mapping operator; and Tone Compressor, which is a global tone-mapping operator. The global version (Tone Compressor), though less powerful in its ability to compress the range, has a more understandable, photo-realistic effect. The local version (Details Enhancer) is shown here with the default settings, and the most extreme and unrealistic settings.

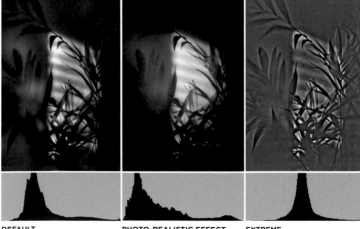

DEFAULT **PHOTO-REALISTIC EFFECT** **EXTREME**

Exposure Blending

I considered dealing with this before HDR imaging, because it is the simpler and less troublesome option for handling multiple exposures, albeit less powerful.

Nevertheless, HDR is what many people turn to first, and the process certainly highlights the more fundamental issues of compressing all possible tones into one image. As a general recommendation, however, I believe HDR and tone-mapping may well be better left to seriously high dynamic range scenes, such as those that include the main light source. Much of the time, when dealing with high range situations covering an order of 10–13 stops, the latest exposure-blending algorithms behave in a more user-friendly way than HDR tone-mapping operators.

There is more than one piece of software that you can use. Photomatix Pro, the leading consumer HDR software, also has several exposure-blending methods that can make pleasing compressions from a range of exposures without having to go down the HDR route.

Photoshop's Mean and Median stacking modes also perform a blend, and the examples on the following pages show the possibilities. As with any compression method, ultimately the choice is best made by comparison and according to your own taste. Some methods are more "photo-realistic," while others are more powerful at bringing everything into range. There is definitely no "objectively correct" image here.

ORIGINAL DARKER EXPOSURE

DOUBLE RAW PROCESSING

One solution for dealing with a high range scene that has been shot in Raw is double-processing, followed by exposure blending. This problematic shot of Sudanese women finishing a meal before boarding a long-distance bus was processed in Photoshop's ACR twice—once for the shadow areas and another for the highlights. Attempting to manage both extreme ends of the scale in a single process failed to satisfy the needs of either, resulting in strong halos around the highlights due to the Recovery algorithm. In this way, each end of the scale could be given a fairly natural treatment. Photomatix Pro was then used to blend the two, although it needed the Intensive option and that involves long processing times.

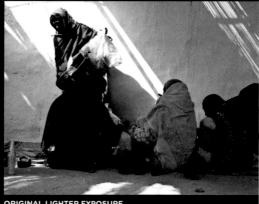

ORIGINAL LIGHTER EXPOSURE

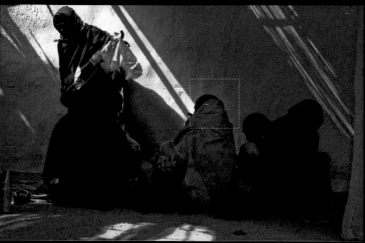

FINAL MERGED EXPOSURE

Fast-track & Foolproof

Technical

The Twelve

Style

POST-PROCESSING

175

Reference

MERGE METHODS

Here, a number of different methods of merging two exposures, one lighter and one darker, are compared against the best possible single exposure (below).

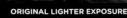

ORIGINAL LIGHTER EXPOSURE

ADJUST

AUTO

INTENSIVE

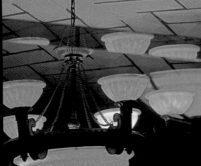

AVERAGE

2 IMAGES

STACK MEAN

Fast-track
& Foolproof

Technical

The Twelve

Style

POST-
PROCESSING

177

Reference

Blending by Hand

Given the recent advances in digital processing and in multi-shot blending and compression techniques, the idea of brushing and erasing layered images by hand may seem primitive.

However, abandoning sophisticated algorithms in favor of using simple tools manually has two compelling advantages. One is that you can see exactly what you are doing, to the pixel if necessary. The other is a reasonable guarantee of a result that looks as most people think a photograph should look like. The major disadvantage with manual brushwork is the time it takes.

There are no arcane techniques, or indeed pitfalls, in manual blending. In principle, nothing could be simpler than taking two or more different exposures, pasting one on top of the other to make a layered file, and then using brushes to reveal the best-exposed areas from each. The most straightforward of all the techniques is to erase the less well-exposed areas from the upper layer, but there are others, including the history brush. For now, we'll keep it simple, with the eraser.

Step one is to copy and paste the images together into one image file, as layers. Step two is to make sure they are aligned. If the bracketed sequence has been shot carefully on a tripod this may not be necessary, although it is safe procedure to examine the file at 100% magnification and click the upper layer on and off

quickly to see if there is a shift. Using Auto-Align in Photoshop is one of a number of ways of doing this. Content recognition is now sufficiently advanced in imaging software for this not to be a serious issue, even if the sequence has been shot handheld.

In the case of two layers, simply use brushes of the appropriate sizes and feathering to erase through the upper layer to the better-exposed areas in the Background layer. Varying the opacity of the brush is another control. For areas that are well-defined segments, such as a window frame, use a selection-making tool, such as a lasso, magic wand, or a path, which is then converted into a selection. The edges of segments are the tricky zones when doing this, but there are a number of ways of modifying the selection, including feathering, smoothing, expanding, or contracting.

FINAL BLENDED IMAGE

HAND BLENDING

Some high-range images are easier to blend by hand than in an automated procedure, and this is one such image. All except two kinds of area were well exposed in the lightest version. The two areas not well exposed were the swimming pool, which has a well-defined edge, and the local areas around the lights near the walls. The first step was to copy and paste the three exposures into a single layered file, with the lightest on top. The next was to auto-align them, although this wasn't strictly necessary as they had been shot using a tripod. Erasing through the three layers was straightforward, beginning with the middle layer to the bottom and finishing with erasing through the top layer. The swimming pool with its straight lines was easy to outline using a path, then converted into a selection, and within this selection a large eraser brush was used. The small individual lights needed no selection, just several dabs of an appropriately sized eraser, feathered and at 33% opacity.

BLOWN HIGHLIGHTS IN LIGHTEST ORIGINAL

ERASER USED ON UPPER LAYER

DARKEST ORIGINAL

PATH DRAWN AROUND THE POOL

LIGHTEST ORIGINAL

Fast-track & Foolproof

Technical

The Twelve

Style

POST-PROCESSING

179

Reference

Glossary

APERTURE
The opening behind the camera lens through which light passes on its way to the image sensor (CCD/CMOS).

ARTIFACT
A flaw in a digital image.

AXIS LIGHTING
Light aimed at the subject from close to the camera's lens.

BACKLIGHTING
The result of shooting with a light source, natural or artificial, behind the subject to create a silhouette or rim-lighting effect.

BALLAST
The power pack unit for an HMI light that provides a high initial voltage.

BARN DOORS
The adjustable flaps on studio lighting equipment that can be used to control the beam emitted.

BARN DOOR TRACKER
A remarkably effective device used by amateur photographers to turn a camera to follow the movement of stars across the night sky.

BIT (BINARY DIGIT)
The smallest data unit of binary computing, being a single 1 or 0.

BIT DEPTH
The number of bits of color data for each pixel in a digital image. A photographic-quality image needs eight bits for each of the red, green, and blue channels, making for a bit depth of 24.

BOOM
A support arm for attaching lights or fittings to.

BRACKETING
A method of ensuring a correctly exposed photograph by taking three shots; one with the supposed correct exposure, one slightly underexposed, and one slightly overexposed.

BRIGHTNESS
The level of light intensity. One of the three dimensions of color in the HSB color system. See also Hue and Saturation

BYTE EIGHT BITS
The basic unit of desktop computing. 1,024 bytes equals one kilobyte (KB), 1,024 kilobytes equals one megabyte (MB), and 1,024 megabytes equals one gigabyte (GB).

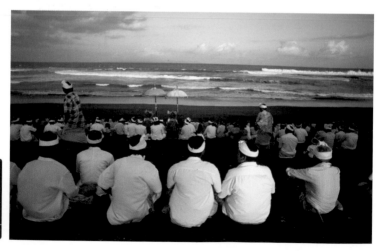

CALIBRATION
The process of adjusting a device, such as a monitor, so that it works consistently with others, such as scanners or printers.

CANDELA
Measure of the brightness of a light source itself.

CCD (CHARGE-COUPLED DEVICE)
A tiny photocell used to convert light into an electronic signal. Used in densely packed arrays, CCDs are the recording medium in some DSLRs.

CHANNEL
Part of an image as stored in the computer; similar to a layer. Commonly, a color image will have a channel allocated to each primary color (e.g. RGB) and sometimes one or more for a mask or other effects.

CLONING
In an image-editing program, the process of duplicating pixels from one part of an image to another.

CMOS (COMPLEMENTARY METAL-OXIDE SEMICONDUCTOR)
An alternative sensor technology to the CCD, CMOS chips are used in ultra-high-resolution cameras from most manufacturers.

CMYK
Cyan, Magenta, Yellow, Key. The four process colors used for printing, including black (key).

COLOR GAMUT
The range of color that can be produced by an output device, such as a printer, a monitor, or a film recorder.

COLOR TEMPERATURE
A way of describing the color differences in light, measured in degrees Kelvin and using a scale that ranges from dull red (1900 K), through orange, to yellow, white, and blue (10,000 K).

COMPRESSION
Technique for reducing the amount of space that a file occupies, by removing redundant data. There are two kinds of compression: standard and lossy. While the first simply uses different, more processor-intensive routines to store data than the standard file formats (see LZW), the latter actually discards some data from the image. The best known lossy compression system is JPEG, which allows the user to choose how much data is lost as the file is saved.

CONTRAST
The range of tones across an image, from bright highlights to dark shadows.

CROPPING
The process of removing unwanted areas of an image, leaving behind the most significant elements.

DEPTH OF FIELD
The distance in front of and behind the point of focus in a photograph, in which the scene remains in acceptable sharp focus.

DIALOG BOX
An onscreen window, part of a program, for entering settings.

DIFFUSION
The scattering of light by a material, resulting in a softening of the light and of any shadows cast. Diffusion occurs in nature through mist and cloud cover, and can also be simulated using diffusion sheets and soft-boxes.

DIGITAL ZOOM
Many cheaper cameras offer a digital zoom function. This simply crops from the center of the image and scales the image up using image processing algorithms. Unlike a zoom lens, or "optical zoom," the effective resolution is reduced as the zoom level increases; 2× digital zoom uses ¼ of the image sensor area, 3× uses ⅑, and so on. The effect of this is very poor image quality; Even if you start with an 8 megapixel sensor, at 3× digital zoom your image would be taken from less than one megapixel of it.

DMAX (MAXIMUM DENSITY)

The maximum density—that is, the darkest tone—that can be recorded by a device.

DMIN (MINIMUM DENSITY)

The minimum density—that is, the brightest tone—that can be recorded by a device.

DYE SUBLIMATION PRINTER

A color printer that works by transferring dye images to a substrate (paper, card, etc.) by heat, to give near photographic-quality prints.

EDGE LIGHTING

Light that hits the subject from behind and slightly to one side, creating flare or a bright "rim lighting" effect around the edges of the subject.

FEATHERING

In image-editing, the fading of the edge of an image or selection.

FILE FORMAT

The method of writing and storing information (such as an image) in digital form. Formats commonly used for photographs include TIFF and JPEG.

FILL-IN FLASH

A technique that uses the on-camera flash or an external flash in combination with natural or ambient light to reveal detail in the scene and reduce shadows.

FILL LIGHT

An additional light used to supplement the main light source. Fill can be provided by a separate light unit or a reflector.

FILTER

(1) A thin sheet of transparent material placed over a camera lens or light source to modify the quality or color of the light passing through.
(2) A feature in an image-editing application that alters or transforms selected pixels for visual effect.

FLAG

Something used to partially block a light source to control the amount of light that falls on the subject.

FLASH METER

A light meter especially designed to verify exposure in flash photography. It does this by recording values from the moment of a test flash, rather than simply measuring the "live" light level.

FOCAL LENGTH

The distance between the optical center of a lens and its point of focus when the lens is focused on infinity.

FOCAL RANGE

The range over which a camera or lens is able to focus on a subject (e.g., 0.5m to Infinity).

FOCUS

The optical state where the light rays converge on the film or sensor to produce the sharpest possible image.

FRINGE

In image-editing, an unwanted border effect to a selection, where the pixels combine some of the colors from inside the selection and some from the background.

F-STOP

The calibration of the aperture size of a photographic lens.

GAMMA

A measure of the contrast of an image, expressed as the steepness of the characteristic curve of an image.

GRADATION

The smooth blending of one tone or color into another, or from transparent to colored in a tint. A graduated lens filter, for instance, might be dark on one side, fading to clear on the other.

GRAYSCALE

An image made up of a sequential series of 256 gray tones, covering the entire gamut between black and white.

HALOGEN BULB

Common in modern spotlighting, halogen lights use a tungsten fillament surrounded by halogen gas, allowing it to burn hotter, longer, and brighter.

HAZE

The scattering of light by particles in the atmosphere, usually caused by fine dust, high humidity, or pollution. Haze makes a scene paler with distance, and softens the hard edges of sunlight.

HDRI (HIGH DYNAMIC RANGE IMAGING)

A method of combining digital images taken at different exposures to draw detail from areas which would traditionally have been over or under exposed. This effect is typically achieved using a Photoshop plugin, and HDRI images can contain significantly more information than can be rendered on screen or even perceived by the human eye.

HISTOGRAM

A map of the distribution of tones in an image, arranged as a graph. The horizontal axis represent the tones from the darkest to the lightest, while the vertical axis shows the number of pixels in that range.

HMI (HYDRARGYRUM MEDIUM-ARC IODIDE)

A lighting technology known as "daylight" since it provides light with a color temperature of around 5600 K.

HONEYCOMB GRID

In lighting, a grid can be placed over a light to prevent light straying. The light can either travel through the grid in the correct direction, or will be absorbed by the walls of each cell in the honeycomb.

HOT-SHOE

An accessory fitting found on most digital and film SLR cameras and some high-end compact models, normally used to control an external flash unit. Depending on the model of camera, pass information to lighting attachments via the metal contacts of the shoe.

HSB (HUE, SATURATION, BRIGHTNESS)

The three dimensions of color, and the standard model used to adjust color in many image-editing applications.

HUE

The pure color defined by position on the color spectrum; what is generally meant by "color" in lay terms.

INCANDESCENT LIGHTING

This strictly means light created by burning, referring to traditional filament bulbs. They are also know as hotlights, since they remain on and become very hot.

INCIDENT METER

A light meter as opposed to the metering system built into a camera. These are used by hand to measure the light falling at a paticular place, rather than (as the camera does) the light reflected from a subject.

ISO

An international standard rating for film speed, with the film getting faster as the rating increases. ISO 400 film is twice as fast as ISO 200, and will produce a correct exposure with less light and/or a shorter exposure. However, higher-speed film tends to produce more grain in the exposure.

Fast-track & Foolproof

Technical

The Twelve

Style

Post-processing

REFERENCE

JOULE

Measure of power, see watt-seconds.

JPEG (JOINT PHOTOGRAPHIC EXPERTS GROUP)

Pronounced "jay-peg," a system for compressing images, developed as an industry standard by the International Standards Organization. Compression ratios are typically between 10:1 and 20:1, although lossy (but not necessarily noticeable to the eye).

KELVIN

Scientific measure of temperature based on absolute zero (simply take 273.15 from any temperature in Celsius to convert to kelvin). In photography measurements in Kelvin refer to color temperature. Unlike other measures of temperature, the degree symbol in not used.

LASSO

In image-editing, a tool used to draw an outline around an area of an image for the purposes of selection.

LAYER

In image-editing, one level of an image file, separate from the rest, allowing elements to be edited separately.

LCD (LIQUID CRYSTAL DISPLAY)

Flat screen display used in digital cameras and some monitors. A liquid-crystal solution held between two clear polarizing sheets is subject to an electrical current, which alters the alignment of the crystals so that they either pass or block the light.

LIGHT PIPE

A clear plastic material that transmits light, like a prism or optical fiber.

LIGHT TENT

A tent-like structure, varying in size and material, used to diffuse light over a wider area for close-up shots.

LUMENS

A measure of the light emitted by a lightsource, derived from candela.

LUMINAIRES

A complete light unit, comprising an internal focussing mechanism and a fresnel lens. An example would be a focusing spot light. The name luminaires derives from the French language, but is used by professional photographers across the world.

LUMINOSITY

The brightness of a color, independent of the hue or saturation.

LUX

A scale for measuring illumination, derived from lumens. It is defined as one lumen per square meter, or the amount of light falling from a light source of one candela one meter from the subject.

LZW (LEMPEL-ZIV-WELCH)

A standard option when saving TIFF files which reduces file sizes, especially in images with large areas of similar color. This option does not lose any data from the image, but cannot be opened by some image editing programs.

MACRO

A mode offered by some lenses and cameras that enables the lens or camera to focus in extreme close-up.

MASK

In image-editing, a grayscale template that hides part of an image. One of the most important tools in editing an image, it is used to limit changes to a particular area or protect part of an image from alteration.

MEGAPIXEL

A rating of resolution for a digital camera, directly related to the number of pixels forming or output by the sensor. The higher the megapixel rating, the higher the resolution of images created by the camera.

MIDTONE

The parts of an image that are average in tone, falling midway between the highlights and shadows.

MODELING LIGHT

A small light built into studio flash units which remains on continuously. It can be used to position the flash, approximating the light that will be cast by the flash.

MONOBLOC

An all-in-one flash unit with the controls and power supply built-in. Monoblocs can be synchronized together to create more elaborate lighting setups.

NOISE

Random pattern of small spots on a digital image that are generally unwanted, caused by non image-forming electrical signals.

OPEN FLASH

The technique of leaving the shutter open and triggering the flash one or more times, perhaps from different positions in the scene.

Fast-track & Foolproof

Technical

The Twelve

Style

Post-processing

REFERENCE

185

PERIPHERAL

An additional hardware device connected to and operated by the computer, such as a drive or printer.

PIXEL (PICTURE ELEMENT)

The smallest units of a digital image, pixels are the square screen dots that make up a bitmapped picture. Each pixel carries a specific tone and color.

PHOTOFLOOD BULB

A special tungsten light, usually in a reflective dish, which produces an especially bright (and if suitably coated, white) light.

PLUG-IN

In image-editing, software produced by a third party and intended to supplement a program's features or performance.

POWER PACK

The separate unit in flash lighting systems (other than monoblocs) which provides power to the lights.

PPI (PIXELS PER INCH)

A measure of resolution for a bitmapped image.

PROCESSOR

A silicon chip containing millions of micro-switches, designed for performing specific functions in a computer or digital camera.

RAID (REDUNDANT ARRAY OF INDEPENDENT DISKS)

A stack of hard disks that function as one, but with greater capacity.

RAM (RANDOM ACCESS MEMORY)

The working memory of a computer, to which the central processing unit (CPU) has direct, virtually immediate access.

RAW FILES

A digital image format, known sometimes as the "digital negative," which preserves higher levels of color depth than traditional 8 bits per channel images. The image can then be adjusted in software—potentially by three stops—without loss of quality. The file also stores camera data including meter readings, aperture settings, and more. In fact each camera model creates its own kind of Raw file, though leading models are supported by software such as Adobe Photoshop.

REFLECTOR

An object or material used to bounce light onto the subject, often softening and dispersing the light for a more attractive result.

RESAMPLING

Changing the resolution of an image file either by removing pixels (lowering resolution) or adding them by interpolation (increasing resolution).

RESOLUTION

The level of detail in a digital image, measured in pixels (e.g. 1,024 by 768 pixels), or dots per inch (in a half-tone image only, e.g. 1200 dpi).

RGB (RED, GREEN, BLUE)

The primary colors of the additive model, used in monitors and image-editing programs.

RIM-LIGHTING

Light from the side and behind a subject which falls on the edge (hence rim) of the subject.

SATURATION

The purity of a color, going from the lightest tint to the deepest, most saturated tone.

SELECTION

In image-editing, a part of an on-screen image that is chosen and defined by a border in preparation for manipulation or movement.

SHUTTER

The device inside a conventional camera that controls the length of time during which the film is exposed to light. Many digital cameras don't have a shutter, but the term is still used as shorthand to describe the electronic mechanism that controls the length of exposure for the sensor.

SHUTTER SPEED

The time the shutter (or electronic switch) leaves the sensor or film open to light during an exposure.

SLR (SINGLE LENS REFLEX)

A camera that transmits the same image via a mirror to the film and viewfinder, ensuring that you get exactly what you see in terms of focus and composition.

SLOW SYNC

The technique of firing the flash in conjunction with a slow shutter speed (as in rear-curtain sync). The result is that motion blur is combined with a moment frozen by the flash.

SNOOT

A tapered barrel attached to a lamp in order to concentrate the light emitted (narrow the beam) into a spotlight.

SOFT-BOX

A studio lighting accessory consisting of a flexible box that attaches to a light source at one end and has an adjustable diffusion screen at the other, softening the light and any shadows cast by the subject.

SPOT METER

A specialized light meter, or function of the camera light meter, that takes an exposure reading for a precise area of a scene.

TELEPHOTO

A photographic lens with a long focal length that enables distant objects to be enlarged. The drawbacks include a limited depth of field across the aperture range and angle of view.

TIFF (TAGGED IMAGE FILE FORMAT)

A file format for bitmapped images that supports CMYK, RGB, and grayscale files with alpha channels, and lab, indexed-color. Now the most widely used standard for high-resolution digital photographic images. Can use LZW lossless compression.

TTL (THROUGH THE LENS)

Describes metering systems that use the light passing through the lens to evaluate the exposure.

TUNGSTEN

A metallic element, used as the filament for lightbulbs, hence tungsten lighting.

UMBRELLA

In photographic lighting umbrellas with reflective surfaces are used in conjunction with a light to diffuse the beam.

WHITE BALANCE

A digital camera control used to balance color settings for artificial lighting types.

Index

Fast-track
& Foolproof

Technical

The Twelve

Style

Post-processing